POVERTY POINT

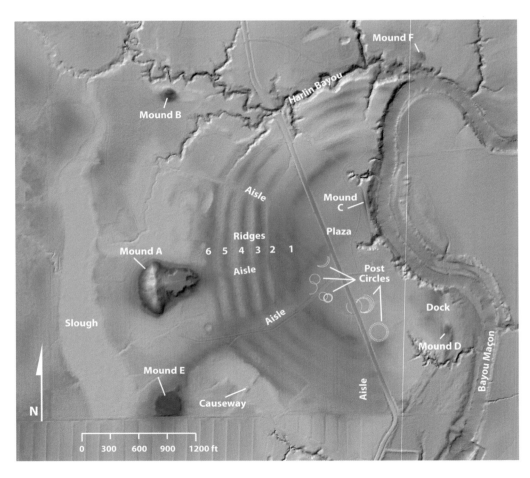

Mound F

Harlin Bayou

Mound B

Aisle

Mound C

Plaza

Ridges

Mound A 6 5 4 3 2 1

Aisle

Post Circles

Aisle

Dock

Slough

Mound D

Mound E

Bayou Maçon

N

Causeway

Aisle

0 300 600 900 1200 ft

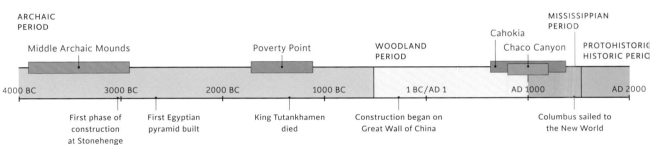

ARCHAIC PERIOD

Middle Archaic Mounds

Poverty Point

WOODLAND PERIOD

Cahokia

MISSISSIPPIAN PERIOD

Chaco Canyon

PROTOHISTORIC HISTORIC PERIOD

4000 BC 3000 BC 2000 BC 1000 BC 1 BC/AD 1 AD 1000 AD 2000

First phase of construction at Stonehenge

First Egyptian pyramid built

King Tutankhamen died

Construction began on Great Wall of China

Columbus sailed to the New World

A UNESCO WORLD HERITAGE SITE

POVERTY POINT

REVEALING THE FORGOTTEN CITY

JENNY ELLERBE and DIANA M. GREENLEE

LOUISIANA STATE UNIVERSITY PRESS
BATON ROUGE

Published by Louisiana State University Press
Copyright © 2015 by Jenny Ellerbe and Diana M. Greenlee
All rights reserved
Manufactured in Canada
First printing

DESIGNER: Barbara Neely Bourgoyne
TYPEFACE: Livory
PRINTER AND BINDER: Friesens Corporation

FRONTISPIECE IMAGE: LiDAR topographic map showing the earthworks of Poverty Point. LiDAR
data courtesy of FEMA and the state of Louisiana, and distributed by "Atlas: The Louisiana Statewide
GIS," LSU CADGIS Research Laboratory, Baton Rouge, Louisiana.

Library of Congress Cataloging-in-Publication Data are available at the Library of Congress.

ISBN 978-0-8071-6021-3 (cloth: alk. paper) — ISBN 978-0-8071-6022-0 (pdf) — ISBN 978-0-8071-6023-7
(epub) — ISBN 978-0-8071-6024-4 (mobi)

"What is the use of a book," thought Alice, "without pictures or conversations?"

—Lewis Carroll, *Alice in Wonderland*

CONTENTS

Note: Words in *italic* are defined in the glossary at the end of the book.

ACKNOWLEDGMENTS

Our thanks to Bill Caverlee for his positive and encouraging comments that helped get this project moving forward. His sharp editorial skills, which he generously applied to multiple drafts, greatly improved the manuscript.

We'd also like to thank David Griffing, Alisha Wright, and Fran Hamilton for their efficient and expert assistance in gathering the artifacts to be photographed from display cases and storage boxes. Those were fun days.

Thanks, too, to the many, many archaeologists, students, and volunteers who have given their time and sweat to the quest to understand and promote Poverty Point. This work was only possible because of their efforts and achievements.

Finally, sincere thanks are due to Jack and Grant Libby for their daily support and encouragement. They may not have written the book, but they did live through it.

POVERTY POINT

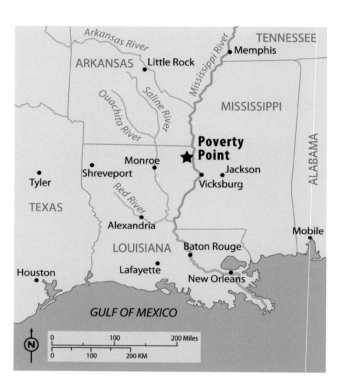

Location of Poverty Point.

PROLOGUE

I am from this place, this flat northeastern Louisiana land, and grew up sur-
rounded by remnants of the ancient mound-building cultures. Their dirt monu-
ments, some over five thousand years old, are scattered all across this landscape.
Most are on private property—in the middle of farmland or hidden behind brush
and barbed wire fences. As a child, I rarely thought of them but now find myself
drawn to them again and again.

Poverty Point is one of the few earthen-mound complexes near my home
that is open to the public. I have climbed to the top of the largest mound there
and felt its sacred ground beneath me. Trying to grasp the idea of an earthwork
that is 3,500 years old is difficult when thirty years ago or even five years ago
can feel so remote. Faced with its age and endurance, I am, in turn, reminded
of my transience, my blink-of-an-eye touchdown on this earth. But walking the
trail at Poverty Point and studying its earthworks help me place my tiny dot of
existence on the timeline of this rich bayou land and deepen my connection to it.

I happened to be visiting the site in late June 2011 as archaeology field-school
students excavated a small pit. They stood deep in the earth in a precisely dug
cube, measuring and diagramming and scraping gently at the dirt.

The assembled crew was researching magnetic anomalies that had been
discovered below the surface, and I tried to eavesdrop while staying out of the
way. In all the years I had been coming to Poverty Point, visiting the small mu-
seum and studying the artifacts in their cases, this was the first time I had been
lucky enough to watch while the archaeologists worked. I was fascinated by the
process—their tools, their precision, and their understanding of the data they
were collecting.

Archaeology student using a plumb bob to determine the location of artifacts encountered during an excavation.

Student measuring the width of an archaeological feature while mapping an excavation.

I mentioned to the group that I was a photographer and that I was embarking on a personal project to document the ancient sites on the Indian Mound Driving Trail. The trail contains nearly forty earthworks in northeastern Louisiana that span roughly 5,000 years of mound building, and I wanted to photograph them all.

Dr. Diana Greenlee, station archaeologist at Poverty Point, told me that she needed photographs for the nomination of Poverty Point to the World Heritage List and asked if I would be interested in helping with that project also. We stood in the heat and the humidity and brokered a deal. And so began my journey to photograph the earthworks at Poverty Point as well as the ones on the driving trail.

I spent the next nineteen months visiting Poverty Point at all hours and in all seasons. The artifacts that I had viewed behind glass for all those years were brought out of their cases for me. I photographed them one after another, relics over 3,000 years old, that I held in my hands, paraded before my camera lens. And I got to ask questions, as many as I could dream to ask, and have them answered by the people most knowledgeable about Poverty Point.

This book rose out of my conversations with Diana, questions that I asked in person or e-mailed or discussed over coffee again and again. Our backgrounds couldn't be more different: Mine a creative one and hers based in science. I am

Steps leading up to Mound A.

from Louisiana; she grew up near Seattle. This book is structured much like our conversations—my wanderings and musings, her research and data. It is a blending of art and science that is meant to expand Poverty Point from just an archaeological site to be studied, to a city and culture to be experienced.

Jenny Ellerbe

The plaza with Mound A in the distance.

INTRODUCTION

Jenny

I am sitting at a picnic table at Poverty Point studying a map of the site. I get my bearings and find my location as if I were embedded in a You Are Here tableau. The earthworks are spread out around me with the ridges curling to my left and right. Bayou Maçon* is behind me and Mound A stands directly in front of me, across the plaza, in a gap between the trees that cover the western ridges.

It's difficult to comprehend that the peaceful setting that surrounds me now was once a metropolis that was active for six hundred years. Poverty Point is a roughly 345-acre Native American site built and occupied from 1700 to 1100 BC, made up of six earthen mounds and nearly six miles of ridges. The design is unlike any other in the world. This hand-built earthen city was the New York City of its day, rising above all others in North America. It contained the largest earthworks and conducted the most long-distance trade of any complex built by hunter-fisher-gatherers anywhere in the world.

Poverty Point was abandoned around 1100 BC by the Native Americans who built it. The bustling city was deserted, the earthworks left to stand above empty ridges and a vacant plaza, their surfaces impacted by centuries of rain and drought, covered by weeds and the windswept dust of the Macon Ridge. Trees sprouted in

*"Bayou Maçon" is traditionally spelled with the cedilla (and pronounced \'mā-sᵊn\), whereas "Macon Ridge" is traditionally spelled "Macon" (and pronounced \'mā-sᵊn\ or sometimes \'mā-kᵊn\). The bayou is thought to be named after a river pirate, Samuel Mason, who was active in this area in the 1790s and early 1800s (McKoin 1971).

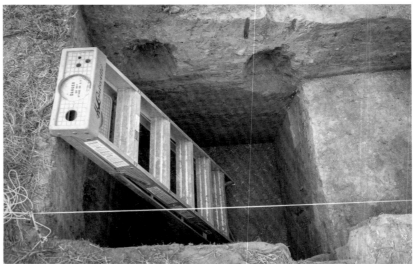

Bones and feathered remains of a hawk.

Excavation pit at Mound C.

a land that was previously open grassland, and quiet descended upon the sacred ground. Today Poverty Point is surrounded by farmland in northeastern Louisiana, about twenty minutes from Interstate 20.

I'm not a scientist and can sometimes get lost in the facts of Poverty Point. As hard as I try to keep them in line, they tend to run together to form stories. I go off to examine the western ridges and discover a scattering of bird bones and my thoughts begin to stray.

And while I love to wander the site aimlessly, it is an empty field to me without information. I can't bring the site to life without knowing that the slight rise I just passed, the site of the bird bones, is the causeway. That it was built roughly 3,500 years ago as safe passage over a five- to six-foot depression in the ground. I can't imagine people treading across that rise without understanding its significance.

Deep in the ground I find the knowledge I need, unearthed for me by the archaeologists and scientists who know this place best. With their research I am able to build Poverty Point, piece by piece, into the vast and intricate city that it once was and bring its dwellers to life.

Diana

Archaeology at Poverty Point began with Clarence Bloomfield (C. B.) Moore. Moore was a wealthy amateur (or "avocational") archaeologist from Philadelphia, who traveled in his steamboat, the *Gopher*, to sites accessible via navigable waterways throughout the southeastern United States. He steamed up Bayou Maçon to Poverty Point in February 1913, and his crew spent two and a half days digging into the mounds and living areas. Moore provided the first detailed description of the mounds and *artifacts* found at the site. And he was impressed by the observation that almost no pottery and no burials were found at this "great aboriginal site,"[1] for both were known at that time to be closely associated with mound sites in the southeastern United States.

In the century since Moore's explorations, numerous archaeologists have worked at Poverty Point. Some have worked alone, or nearly so; some have hired seasoned crews or brought college students eager to learn how to use the tools of the trade to dig square holes with straight walls, to identify different kinds of artifacts, to recognize pits and hearths and *postholes*, and to keep the detailed records that allow archaeologists to make sense of what they've found. Some worked a few short days, others a field season or two, and others far longer. Even so, less than 1 percent of the site has been excavated.[2] There have been archaeologists who didn't excavate, who instead used techniques that have less impact on the ancient remains. And there have been archaeologists who didn't work in the field at all, but spent hours and days and months classifying, cataloging, and studying the accumulated artifacts.

Through this research, we continue to refine our understanding of Poverty Point. We collaborate with scientists having expertise in complementary subject areas (e.g., animal bones, plant remains [pollen, wood, seeds], rocks and ores, soils, river dynamics, *geophysical survey*, and dating, to name a few) to expand our grasp of Poverty Point. When and how different parts of the site were built, what the people ate, where they acquired their resources, how they made and used their tools—these are among the issues being pieced together through careful study. And with those pieces we weave together the story of Poverty Point and the people who built it.

I PRE-POVERTY POINT

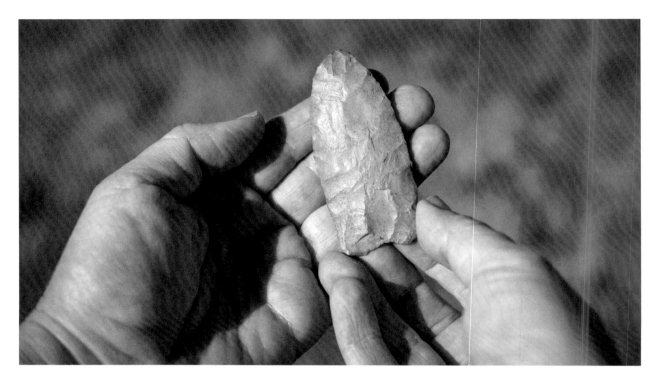

Clovis point.

1 PALEOINDIANS

Jenny

People had been walking this land for thousands of years before the culture at Poverty Point came into being. They crossed into North America from Asia during the Ice Age, traversing a land bridge that was open for millennia before the ice melted and the sea waters rose and covered it once again. They made their way across what is now the southern United States as nomads, following the seasons, going where they could find food, moving on when no more was available. They gathered fruits and nuts and hunted wild game, including many animals such as woolly mammoths and mastodons, which are now extinct. They made stone points that they attached to spears, which they hurled at or jabbed into their prey. Many of those stone points were dropped, lost, left behind. And a few of them have been found at Poverty Point, deposited on the ground high atop the Macon Ridge, hidden for thousands of years until some other wanderer discovered them again.

Since some of these stone points date back to around 13,000 years ago, it is remarkable that they still have somewhat sharp edges, their surfaces uneven with the scars from each flake that was removed to give them their shape. They may appear to be simply archaeological specimens, objects to study and date, but to me they resonate with stories. I hold them and feel the flesh of the hands that made them, the ones that used them, and the animals who lost their lives to their deadly points.

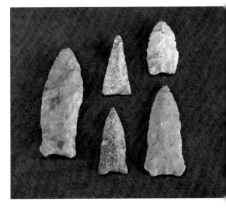

Paleoindian spear points.

Diana

People were here at Poverty Point long before the earthworks were built. We know this because they left *diagnostic artifacts* behind. For example, we have Clovis spear points. You can distinguish a Clovis point by its lanceolate (leaf) shape and the shallow groove (called a "flute") created on each face by striking a flake from its concave base. Clovis points vary a lot in size, workmanship, and the type of stone used. But the flute is the give-away. Based on their associations with extinct animals and on *radiocarbon dating*, we know that they were made about 13,000 years ago (with *calibration*, that's 11,000 BC), corresponding to the Paleoindian period (11,500–8000 BC in Louisiana).[1] Although Clovis points enjoy the reputation of being spear points designed specifically to bring down *megafauna* like mammoths and mastodons, *use wear* studies indicate that Clovis points were the original American multi-tools, prehistoric Leathermans. Deer, bison, bear, and rabbit blood residues have been found on Clovis points from Ohio,[2] and some Clovis points were used as knives for cutting plants and meat.[3]

Clovis points and other diagnostic artifacts that predate the earthworks make up only a tiny fraction of the artifacts from the site, maybe enough to fill a baseball cap. They tell us that people camped in this location long before any earthworks were built. Of the people, we know relatively little. Certainly they were Native Americans and hunter-gatherers. Across Louisiana, we see evidence that, over time, people "settled in" to their environment, ranging over ever-smaller territories and making greater use of an expanding set of resources with an increasing variety of tools in their kits. They left a light footprint on Macon Ridge, invisible to the untrained eye, until Middle Archaic times (5000–2000 BC).

2 LOWER JACKSON MOUND

Jenny

I leave the two-lane highway near Poverty Point and drive along the soft ground of a turnrow, narrowly missing a large white-tailed doe that disappears into the woods. Having secured permission to visit this privately owned site, I park my car and climb to the summit of the Lower Jackson Mound.

Built sometime after 3950 BC, Lower Jackson is from the Middle Archaic period, and it is one of the rare places where hunter-gatherers first began to alter their landscape by building earthen mounds.

I walk among tombstones marking a small cemetery that was added to the mound's top in the mid-1800s and stare out over the surrounding farmland. Standing nine feet above the rows of cotton that encircle me, I think about the Middle Archaic culture and wonder how these hunter-gatherers came upon the idea to claim this place as their own. What prompted them to begin gathering dirt to build such a structure? After roaming this area for roughly 7,000 years without building mounds, why did they begin?

The Lower Jackson Mound is one of the oldest man-made earthen structures in the Western Hemisphere, and I would expect it to be celebrated and well known. Instead, it is tucked away in a cotton field in rural northeastern Louisiana. There is a simple sign next to the highway that explains its significance, but nearly everyone passes by without noticing it.

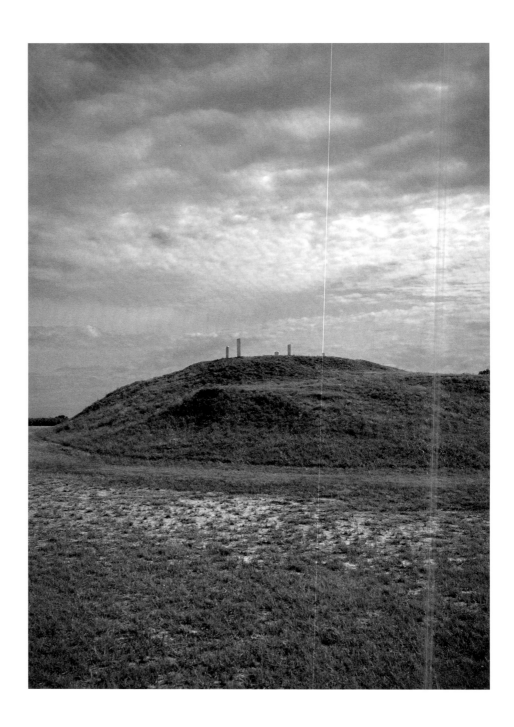

Lower Jackson Mound.

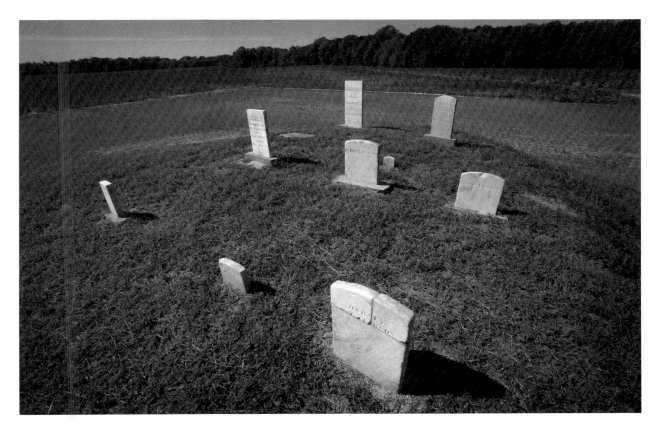

After Lower Jackson was built, other mounds were created in the area for the next 1,000 years. Then, sometime around 2900 BC, the Middle Archaic people stopped building earthworks. The construction ceased as inexplicably as it began. The last clearly dated Middle Archaic construction was the addition of a final stage to Mound A at Watson Brake, roughly 46 miles southwest of Poverty Point.

Historic cemetery atop the Lower Jackson Mound.

Cotton adjacent to the Lower Jackson Mound.

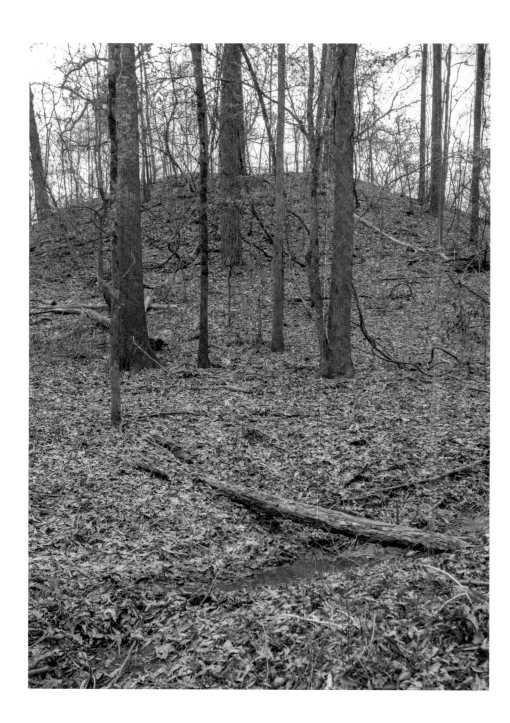

Watson Brake, Mound A.

Diana

None of the hunter-gatherer groups encountered by sixteenth- to nineteenth-century European explorers in Africa, Australia, the Americas, or elsewhere were known to build earthen mounds. They were thought to be engaged in a daily struggle just to survive, and they certainly didn't seem to be sufficiently organized to mount and lead a labor force that could produce monumental architecture, even if they wanted to. So archaeologists didn't think hunter-gatherers could build mounds. When radiocarbon dates from some of the earthworks in Louisiana indicated they were built during the Middle Archaic period, before agriculture was established, it was simply easier to think that somebody had made a mistake while excavating or that a date was contaminated than it was to accept how old they were.

In the mid-1990s, archaeologist Joe Saunders, soil scientist Thurman Allen, and avocational archaeologist Reca Jones built the case for Middle Archaic–period mounds.[4] Through careful excavation and coring, detailed dating, and thoughtful analysis, they accumulated overwhelming evidence for six Middle Archaic earthworks in northeastern Louisiana, including Lower Jackson Mound, and in so doing, they removed all doubt that the dates were authentic. Altogether, sixteen Middle Archaic mound sites in Louisiana and Mississippi are now recognized.[5]

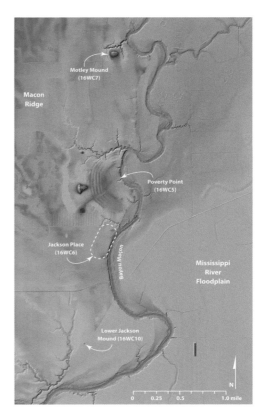

LiDAR topographic map of Macon Ridge and the adjacent floodplain, with earthworks identified, including Lower Jackson Mound and Jackson Place mounds. LiDAR data courtesy of FEMA and the state of Louisiana, and distributed by "Atlas: The Louisiana Statewide GIS," LSU CADGIS Research Laboratory, Baton Rouge, Louisiana.

In addition to marking their physical presence on the landscape by building earthworks, Middle Archaic cultures show a degree of sophistication, what Saunders calls precociousness, that was not present in earlier times. After spending hundreds or thousands of years returning to the same places year after year, mostly near rivers or lakes or the Gulf Coast, they appear to have made the jump to residential stability, living in the same place year-round. Most sites indicate a heightened focus on aquatic resources, like fish, mussels, snails, and turtles, in addition to common terrestrial foods like hickory nuts, deer, rabbits, and squirrels. Artifacts reflect innovations in cooking, tool manufacture, and decorative ornamentation.

Lower Jackson Mound, which is located about 1.8 miles south of Poverty Point's center, was at one time thought by archaeologists to be part of the Poverty Point earthworks complex. But the work of Saunders and his colleagues demonstrated that it is much older than Poverty Point.[6] Lower Jackson was built during the Middle Archaic period (5000–2000 BC), whereas Poverty Point was built during the Late Archaic period (2000–500 BC). A few diagnostic Middle Archaic artifacts (Evans-type spear points, fired earth cubes, and a locust effigy bead) have been found at Poverty Point—not enough for us to infer intensive use of this site, but Middle Archaic people certainly were here.

Why did Middle Archaic people start building mounds? We find very little evidence within these earthen structures for how they were used. They were not cemeteries or platforms for temples or other special buildings, which is how some later groups used mounds. Several other purposes for mounds have been suggested over the years: territorial markers, astronomical observatories, status symbols, defensive structures, symbolic reenactments of origin myths, and religious features, to name a few. The problem we have explaining mounds in this way is that it's impossible to know the intentions behind the effort, what people were thinking as they piled that dirt. Some archaeologists, and I count myself among them, focus not on how ancient peoples justified earthwork construction to themselves, but on the large-scale and probably unintended effects that mound building had on the population, which can be explained.[7]

The act of doing something like building a mound, something that doesn't really benefit survival and reproduction, and, indeed, uses calories and time that

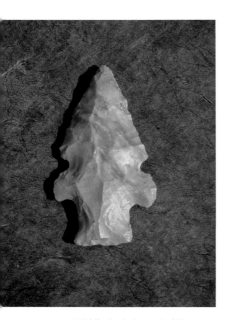

Middle Archaic–period Evans point found at Poverty Point.

could be channeled toward ensuring one's family's survival, is considered "wasteful." It's like driving a Lamborghini instead of a Ford. Things that are apparently wasteful, what we call *cultural elaborations*, can serve an important function by, for example, informing both potential allies and competitors that you've got a lot of resources and/or manpower at your disposal.[8] Like Lamborghinis, mounds send a message.

Mound building and other cultural elaborations appear to provide additional benefits for the groups who do them. For one thing, community members working together toward a common goal are likely to develop strong social ties that could benefit them at some future point through the sharing of information, resources, and/or labor. And, by not exploiting available resources to the maximum, these groups maintain their population levels below the *carrying capacity* of their environment. We call it *bet-hedging*, a name that seems to imply some conscious decision on the part of individuals to lower their reproduction rates, but we don't think that was the case at all. Instead, lower population levels were an unintended consequence of these kinds of activities.

In practice, bet-hedging means that a group isn't as stressed during a time of environmental downturn, when sufficient resources might not be as easily acquired, as groups that do not waste and thus live closer to their environment's carrying capacity. The former can stop their wasteful activities and use that extra time and energy to provision themselves, while the latter, who have been operating at or near their maximum effort, often experience a population crash or even extinction. Over time in an unpredictable environment, bet-hedging groups will outsurvive other groups.[9]

By about 2800 BC, Middle Archaic people had apparently stopped building mounds.[10] At least that is how it looks. Something must have happened, and across a large area. There are independent data suggesting that climatic conditions changed at around that time in the Lower Mississippi Valley, becoming cooler and wetter, with episodes of flooding and more numerous Gulf storms.[11] These were the kinds of conditions for which we would predict a group to cease wasteful activities and focus their energies on survival until the environmental situation improved. That is what appears to have happened.

II THE CITY OF POVERTY POINT

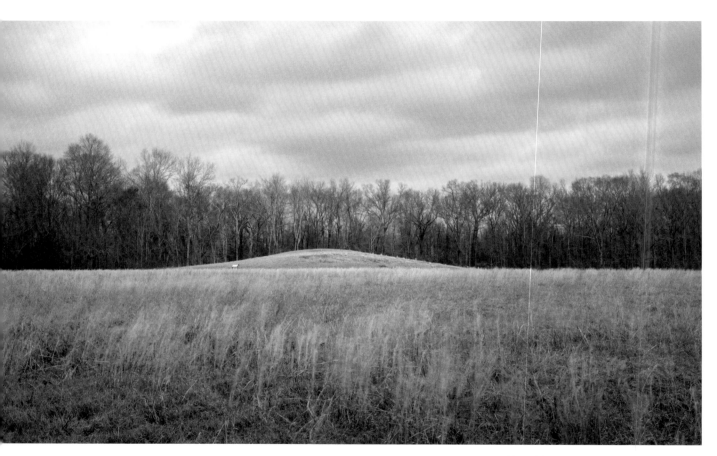

Mound B.

3 MOUND B

Jenny

Atop the Macon Ridge and near the slow-moving Harlin Bayou, I find what is now called Mound B. It is where someone, an entire group of someones, stood, pointed, and said "here." After 1,000 years of not building earthworks in this region, of being content to live in the shadow of other older, ancient mounds, they began building again. I want to know why.

I gaze at Mound B and think of sore muscles and dirty hands and envision the workers watching their first mound rise from ground level to . . . this, to more than this, to what it was when it was originally built.

I stand on the top and look north at the diminutive Harlin Bayou, which would have been just a trickle back in Poverty Point times. Raccoons leave their footprints along the water's edge and a pileated woodpecker calls in the distance.

Beyond the trees to the south, past the adjacent farmland, on a direct north-south line 2.1 miles away, stands the Lower Jackson Mound. It is no coincidence that Mound B is located here. Someone calculated that direct line and knew that when they pointed "here," and building began, that they were connecting their new culture to an ancient one and to an earthwork built 2,000 years before.

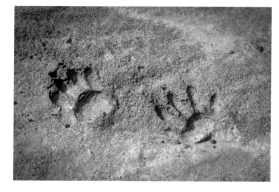

Raccoon prints at Harlin Bayou.

Looking south from Mound B.

Diana

Common sense suggests that there should be a long, continuous tradition of building mounds that increase in size and complexity over time. So it is tempting to think of Lower Jackson Mound as the training-wheels version of the Poverty Point earthworks, but that isn't quite right. Poverty Point doesn't appear until about 2,000 years (that's 100 generations) after Lower Jackson and, remember, there was a time in between when people were not building mounds.

Poverty Point–aged artifacts are found near Lower Jackson Mound and a single Poverty Point–style plummet was buried two feet deep in one of the mounds at Watson Brake, another Middle Archaic mound site in northeast Louisiana.[1] The people of the Poverty Point culture* clearly knew about the Middle Archaic mounds, maybe through oral history or maybe through observation. There's no way to know how they knew. But the Middle Archaic mounds were part of their world. Thus, mound building probably wasn't reinvented by the people of Poverty Point so much as restarted, with an ancestral nod toward Lower Jackson Mound.

Why did people in the Lower Mississippi Valley start building earthworks again during the Late Archaic period? We cannot know the reasons they gave for doing so. Evidence suggests that the environmental downturn that coincided with the end of Middle Archaic mound building ceased after about 1,000 years, a little before the time that construction began at Poverty Point.[2] This doesn't mean that environ-

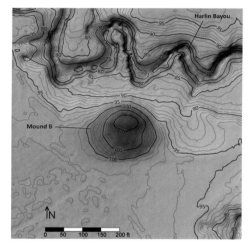

LiDAR topographic map of Mound B. LiDAR data courtesy of FEMA and the state of Louisiana, and distributed by "Atlas: The Louisiana Statewide GIS," LSU CADGIS Research Laboratory, Baton Rouge, Louisiana.

*The Poverty Point culture is recognized at sites other than the "type" site, Poverty Point, by the presence of several diagnostic artifacts including: Poverty Point Objects (see chapter 15), hematite and magnetite plummets, microliths, steatite vessels, beads and other lapidary items, fired-earth figurines, and fiber-tempered pottery (Webb 1982).

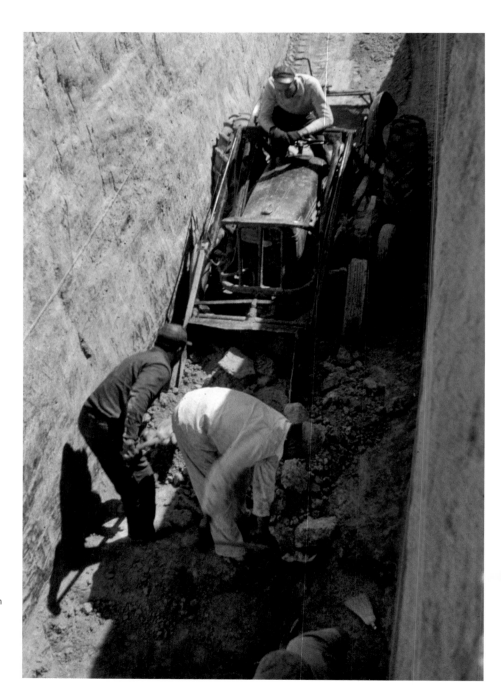

Tractor cutting a trench through
Mound B. Photo (No. 11884)
courtesy of the Museum of
Anthropological Archaeology,
University of Michigan.

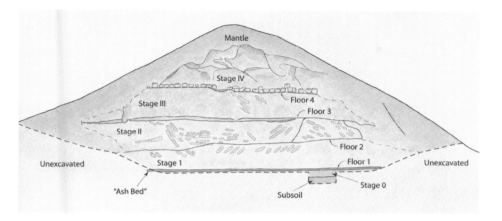

mental change caused people to start building mounds, but instead it provided the right conditions under which groups who built mounds and practiced other cultural elaborations could be successful. And the people of Poverty Point were, by all indications, very successful. Poverty Point began with Mound B, a conical mound that is today about 21 feet tall and 180 feet in diameter.

Mound B was excavated by archaeologist James A. Ford and his colleagues in 1955.[3] They rigged a tractor with blades that allowed them to scrape away the soil 1½ inches at a time, creating several 9-foot-wide trenches through the mound. Archaeologists walked behind the tractor each time it made a pass, collecting artifacts and looking for evidence of mound construction or other ancient activities. Sometimes the earth was so compacted that it had to be broken up before it could be removed by the tractor. This is not the approach that we take at Poverty Point today, but back then it was considered acceptable practice.* And, in truth, it gave them an excellent view of the mound's interior.

As archaeologists excavate, they look for slight differences in the color, texture, and compactness of the dirt. For Ford and his colleagues, these kinds of changes

Profile, or cross-section, map of the north wall of the trench through Mound B, showing different construction stages. Redrawn from Ford and Webb (1956, 36) and Kidder, Ortmann, and Allen (2004, 100); color added.

*Archaeologists today are more mindful of our role as stewards of archaeological sites than in Ford's day. This means that we want to minimize damage to this nonrenewable resource by our research. Whenever we excavate, we destroy the very thing we study. So, we try to use less intrusive methods, like geophysical survey and soil coring, to answer research questions. When we do excavate, we try to excavate small areas, large enough to answer our questions but not overly large, and we keep detailed records of the work.

in Mound B allowed them to understand how the mound was built and provided a glimpse into how it was used. The lowest level was composed of what looked like a 6-inch layer of ash.* Above that were four main stages of construction, the first three resulting in a series of raised, flat surfaces or floors. The final stage was a conical cap, or mantle, of earth placed over the whole mound.

Within each of the mound stages, the archaeologists could see individual basketloads of dirt used to build the mound. Basket loading produces distinct deposits of different colors and textures because the dirt in each basket was slightly different from that in the others. The shapes of the basketloads vary depending on whether the construction involved piles (like haystacks) or thin layers (like pancakes) of soil. The archaeologists also found firepits, charred wood, and possible *postmolds* (stained soil left by decaying posts) on the surfaces within the mound.

Ford found little chunks of charred cane in that "ash bed" near the bottom of the mound, and he collected them and sent them off for radiocarbon dating. Three samples were submitted to professional laboratories and two went to Fred Schatzman, a fifteen-year-old New Jersey high-school sophomore who had built his own radiocarbon laboratory in 1955. (I couldn't have done that when I was in high school!) Radiocarbon dating was a new technology back then and scientists were still working out the kinks. As a set, the five dates varied quite a bit, and, using modern calibration software,[4] the ages range from 1690 BC to AD 60. Ford just said 700 BC. Even though archaeologists recognize that those dates have unacceptably large errors and we don't use them anymore, the 700 BC estimate still shows up from time to time in popular publications and online sources.

More recently, though, archaeologist Anthony Ortmann obtained a piece of charred wood from that same layer in Mound B. His sample, using newer radiocarbon dating methods, dated to 1740–1530 BC.[5] That is the earliest radiocarbon date from an earthwork at Poverty Point, and it is more consistent with other dates from the site than Ford's estimate.

About 10 feet below Mound B's summit, Ford and his crew encountered about 100 brown circular stains, 1–2 feet in diameter. At first, they appeared to be post-

*Recent research by archaeologists suggests that the "ash bed" isn't ash at all, but a layer of fine, gray silt (Kidder, Ortmann, and Allen 2004). They also found that Ford had not quite reached the true base of the mound, and there were two additional construction steps that he didn't recognize.

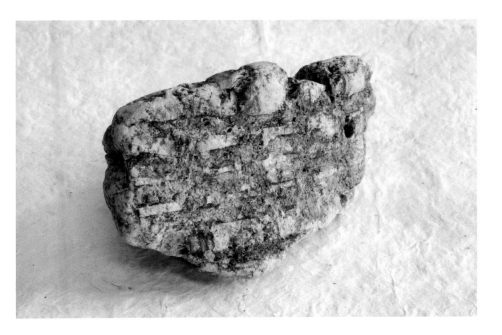

molds. But the outlines of adjacent circles were flat where they touched, as if they were flexible and conformed to each other's shapes. Closer examination of some stains showed impressions of weaving, characteristic of baskets. These impressions were formed when baskets, full of earth, were left at the top of one of the construction stages. Dirt was placed on and around the baskets in the subsequent construction stage. The earth molded itself around the containers, and although the containers did not survive, their traces were visible to the archaeologists. Most containers appeared to have a smooth surface as if they were bags made of animal hide, rather than baskets.

From the stains, Ford and his colleagues could estimate the size of the containers that were used to haul the earth and build the mound. They suggested that the average container would have held about 50 pounds of earth.[6] Knowing that, and given the dimensions of the mound today and the average weight of silt-loam soil, we estimate that Mound B's construction required about 6,970 tons, or 278,800 basketloads, of dirt.

Basketry stain and impression on soil from Mound B.

Mound E.

4 MOUND E

Jenny

I walk through acres of dry, cut grass that rests like tufts of hay on the soft ground. All is beige and dormant. From the empty expanse of ocher, a dozen small birds rise before me, as if they were born of the brownness and released at the sound of my footsteps. I walk on, and it happens again and again. From nothing, from the grass . . . flocks of birds. And so the Poverty Point people appear before me at times, when I least expect them, when I am walking their city, when they rise from seemingly nowhere.

The bare trees of Mound E are silhouetted against the winter's day and create a boundary between the border of Poverty Point and the farmland to the south. Mound E lies on the same north-south line that connects Mound B and the Lower Jackson Mound.

There was once more to Mound E, but the modern-day bulldozers of private landowners removed portions of it in the 1970s, slicing away the backside. What remains is protected from further destruction.

Archaeologists initially thought it was a man-made mound, then a natural knoll, then finally proved it to be part of the Poverty Point complex, built about the same time as Mound B. It has a flat top and feels different to me than the rest of the mounds, a large rectangle on the outskirts of town. When cored in 2011, small flakes of nonlocal stone were discovered, dropped by the people who built it or walked upon it thousands of years ago.

Flakes found at Mound E.

31

Diana

Yes, it's true. Archaeologists had a difficult time coming to a decision on Mound E. C. B. Moore thought it was a mound in 1913. James Ford did not identify it as a mound in his 1954 map of Poverty Point. The power company spaced supports of a 115-kilovolt electrical transmission line in 1967 to avoid Mound E, just in case it was later determined to be culturally important. In 1972, because it was considered a natural part of the landscape, Mound E wasn't included in its entirety when the state of Louisiana purchased Poverty Point. The southernmost quarter of the mound extended beyond the park property. That part of the mound was mostly leveled in 1975 by the landowner. If you know where to look, you can still see a remnant, a little bump on the land, south of the park.

LiDAR topographic map of Mound E. LiDAR data courtesy of FEMA and the state of Louisiana, and distributed by "Atlas: The Louisiana Statewide GIS," LSU CADGIS Research Laboratory, Baton Rouge, Louisiana.

The *soil cores* extracted from Mound E by archaeologist William Haag in 1975 appeared to be natural, what one would expect for soils in this area. A 13-foot-high, subrectangular mound, about 300 by 360 feet at its base, with a flat top and a thin, ramplike appendage extending from the northeast corner, is not consistent with a natural geological landform in this environment. Thus, the mound's form led some researchers to speculate that it was a natural ridge sculpted by people.[7]

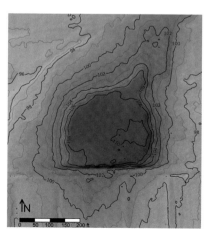

Archaeologist Jon Gibson and soil scientist Arville Touchet were apparently not entirely satisfied with Mound E's sculpted-by-people identity. They cored Mound E in 1983. They cored it again in 1993. Finally, they found two types of soil that did not belong together naturally, situated one right on top of the other in a core. The only way that could happen was if people placed those two kinds of dirt together as fill in the mound. So, eighty years after Moore had called it a mound, it was a mound again. This time for good.

Ortmann excavated along the southern face of the mound in 2001.[8] He found multiple construction stages, somewhat similar to Mound B. Unfortunately, no diagnostic artifacts were recovered, no *features* with datable charcoal were found, and there was no topsoil underlying the mound (it had been stripped away by the builders as the first step in mound construction). He tried to use *luminescence dating* to measure when the soils used to build the mound had last been exposed to sunlight, but the results were inconclusive.

There is another approach that has been used to date mounds in Louisiana that relies on the natural process of soil formation, or *pedogenesis*, to estimate the relative age of different earthworks.[9] A mound with better defined soil layers, or horizons, near its surface is older than one with less distinct horizons; if the horizons are similar between the two mounds, then they're about the same age. In particular, the thickness and clay content of the horizon beneath the topsoil—known as an "argillic" horizon—are key indicators of the soil's age. To determine a mound's relative age using pedogenesis, archaeologists don't have to excavate; we can analyze soil cores. This approach is less destructive to the mound than excavating in search of features or artifacts.

Thurman Allen, Joe Saunders, and I extracted soil cores from Mound E in 2011. We compared the soils in Mound E with those from other mounds at Poverty Point and with the much older Lower Jackson

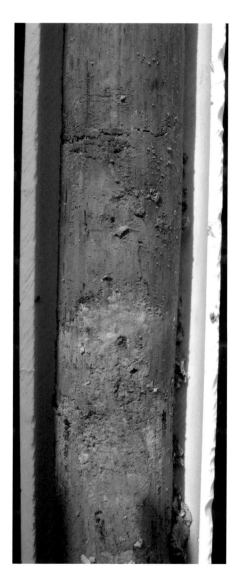

Segment of a soil core from Mound E. The light gray silty layer in the center of the photograph does not occur naturally at this depth and in this topographic setting, and thus is evidence that the mound was built by people. Photo by Diana Greenlee.

Mound. We determined that soil horizons in Mound E were less developed than Lower Jackson Mound and about the same as Mound B. So, Mound E is probably about the same age as, or maybe a little younger than, Mound B. That is the best we can say right now.

Some people know this mound as "Ballcourt Mound." Minds may immediately jump to thoughts of Mayan ballcourts and wonder about ancient cross-cultural contacts, but that's not the intended connection. Instead, archaeologists saw two depressions in the mound's surface about the size and shape of worn spots around backyard basketball hoops. Hence, the ballcourt reference. Common names, like Ballcourt Mound, don't have any relevance to our understanding of history at the site and they tend to cause confusion, but even though we don't really use them anymore, they persist.

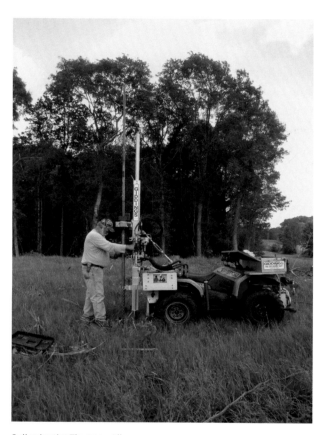

Soil scientist Thurman Allen extracting a soil core from the top of Mound E using a hydraulic coring rig. Photo by Diana Greenlee.

5 THE SLOUGH

Jenny

I leave Mound E and walk northwest toward the slough. Today it is full of water from recent rains and pierced with the sound of wood ducks. Obscured by the brush, I can only listen as they call to one another with their plaintive voices. As I skirt the muddy margins they hear me and take flight, wings beating against the water, still hidden from sight but audibly asserting their presence.

I learn to listen for the unseen.

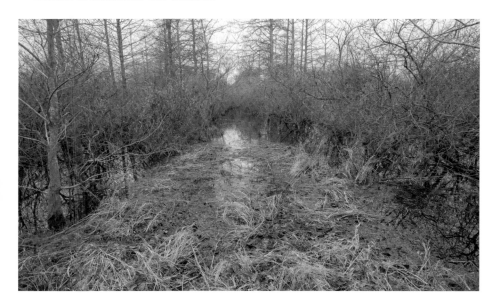

The slough.

Diana

The depression running along the western edge of the site was suspected, for many years, to have been a borrow pit, the source of dirt for building the earthworks. It was close, it was big, and all of that dirt had to have come from somewhere. So, why not there?

In 2010, archaeologist Elizabeth Scharf extracted some soil cores from the slough.[10] The cores showed a continuous influx of sediments from the bottom of each core to the top. There was no cut, a boundary that would be created when dirt was "borrowed" from that place to build a mound. Either her cores did not penetrate deeply enough or the slough was not a borrow pit. She submitted a sample from near the bottom of her longest, deepest core (4.7 feet) for radiocarbon dating and the result came back: 4940–4720 BC. The depression was there long before Poverty Point came into being and has been infilling steadily ever since.

There are other depressions on the site that are likely borrow areas, but they aren't as obvious or as big as the slough. They have not been seriously investigated yet.

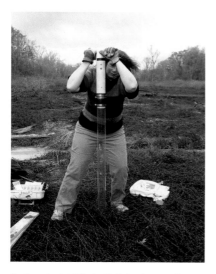

Archaeologist Elizabeth Scharf manually extracting a soil core from Poverty Point's slough. Photo by Diana Greenlee.

6 THE PLAZA AND RIDGES

Jenny

The Poverty Point people lived in the wide open space east of Mounds B and E and the slough where numerous artifacts have been found. The area is flat and now dotted with the occasional armadillo hole and fire-ant bed.

No one is sure how long they lived in that area before someone had an idea to build an earthen ridge within that open space. A ridge where they could build their houses and keep them above the muddy ground below. Maybe they initially planned just one ridge and after that kept building until they created six of them. Or maybe they were all in the design from the beginning. When completed, there were six semi-elliptical ridges that, if laid end to end, would equal nearly six miles. It amazes me that they would undertake such a labor-intensive project that would ultimately create a design that hasn't been duplicated by any other hunter-gatherer group anywhere else in the world.

In an aerial view of Poverty Point, the concentric ridges are the most obvious feature of the site. Their unique design gives the city its defining architecture and holds the mounds together into a cohesive structure.

But from the ground, they are nearly invisible. You could walk right over the southern ridges and never know they were there if not for the markers and the way the grass is mown around them. The western ridges are taller and easier to see, especially when they are covered in early morning mist.

The plaza.

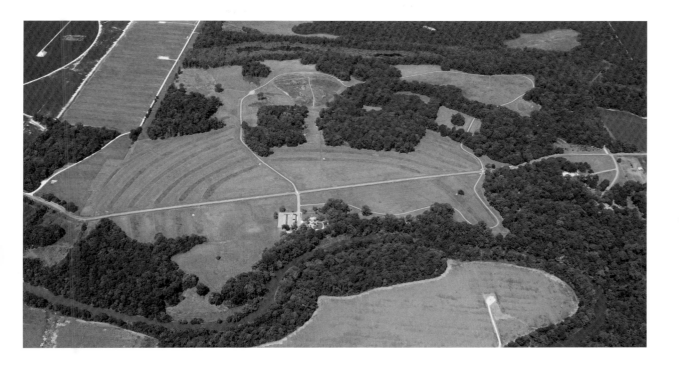

After a hard rain, water collects in the swales between the northern ridges, and I can see why elevating their houses was a good idea. I have walked there and watched as wood ducks took flight as I approached.

While the ridges are the least noticeable feature from the ground, they feel the most alive beneath my feet. They are where the Poverty Point inhabitants lived, where they built their homes and cooked their food in earth ovens. The ridges contain tons of ancient debris and stretch around the plaza as if wrapping their arms around a village square, or in this case, an ancient oval.

Poverty Point from the air. The ridges appear as dark, concentric, C-shaped lines. Photo by Susan Guice.

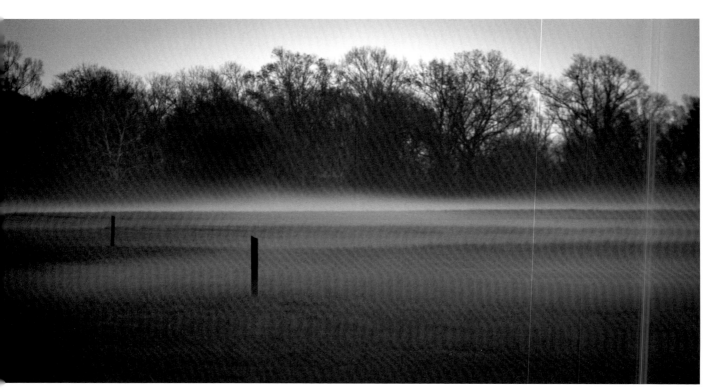

The western ridges covered in early morning fog.

The northern ridges.

Diana

We know that people lived in the area east of Mounds B and E because their habitation debris was buried under later constructions. Hearths, postmolds, and *midden*s are preserved under what we call the ridges: six concentric, C-shaped, earthen features with an outer diameter of nearly ¾ mile. The ridge crests are roughly 80–100 feet wide, separated by swales, or ditches, 60–100 feet wide that were created when earth was borrowed to build the ridges. The ridge system makes Poverty Point unique among archaeological sites—there isn't anything like Poverty Point's ridges anywhere else in the world.

That said, the ridges are so large and so subtle that they are difficult to recognize on the ground, unless there is somebody to point them out, to show you what to look for. In fact, nobody knew about them until James Ford looked at an aerial photograph of Poverty Point. In a 1989 seminar at Louisiana State University, William Haag told the story:

> Talking about this idea of how Poverty Point was discerned as being a great earthworks . . . We didn't realize there was this big earthworks until I went up in April of '53 to meet James Ford. He came down from New York and we were going to plan what to do the summer of '53. And he stopped at the Corps of Engineers headquarters in Vicksburg and picked up some aerial photographs. So, I met him at our normal meeting place, the Hilltop Motel in Delhi, and, also as was normal, after two drinks, he produced these aerial photographs. My gosh, here was this earthworks showing up and he said, "You know where that site is?" And I said, "Well, it's got to be in the Ohio River Valley—no place, except that area, in the East where you get these complex earthworks like that." Well, he said, "You've walked all over that site." And I said, "Not I, I've never been on that site." And then I looked closer and . . . that's Poverty Point! And, of course, we'd known about Poverty Point since 1911 as a site, but not that those earthworks were there . . .[11]

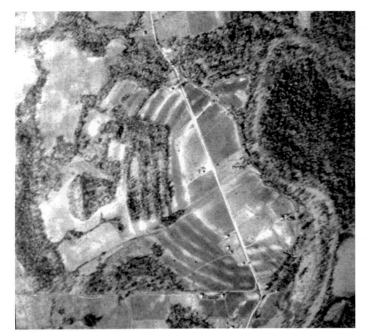

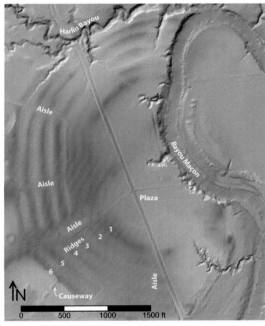

For reference, the ridges are numbered 1–6, with Ridge 1 being the innermost construction and Ridge 6 being the outermost one. The ridges are divided into segments by aisles that cut through the ridges in the south, the southwest, the west, the northwest, and maybe the north (we are still investigating a possible north aisle).

To Ford, the aisles gave the ridge system an octagonal look.[12] Indeed, Ford thought the ridges represented about half an octagon, and he surmised that the missing half had simply washed away. We don't think that today. After studying the history of the river system, examining the ridges and swales near the eastern bank of Macon Ridge, discovering huge filled gullies under some of the ridges along the eastern edge of Macon Ridge, and recovering Poverty Point artifacts in the fields east of Bayou Maçon, we think the site was never a complete octagon.[13]

Aerial photograph of Poverty Point, 1946. Photo courtesy of the U.S. Army Corps of Engineers, Vicksburg District.

LiDAR topographic map of the ridges and plaza. LiDAR data courtesy of FEMA and the state of Louisiana, and distributed by "Atlas: The Louisiana Statewide GIS," LSU CADGIS Research Laboratory, Baton Rouge, Louisiana.

Yes, Bayou Maçon has nibbled at the site along its eastern edge, but it hasn't taken that big of a bite.

Today, the ridges vary in height from a few inches to nearly six feet. It used to be supposed that they were originally 6–9 feet, or higher, over the entire ridge system, and that the lowest areas had been much reduced by some 3,000 years of natural erosion and 130 years or more of cultivation. Surely those processes have lowered the ridge tops, but excavations indicate that the least distinctive ridges, in the southwest sector of the site, were never as pronounced as the most prominent ridges, in the north sector. The natural tilt of the landscape means that the southern part of the site is higher than the northern part—if the builders wanted to maintain a level ridgetop, they would need to build it up more in the north than in the south. This could explain why the ridges are more pronounced in the north than the south.

One of the first things that visitors suggest when they see the ridges is that it's an amphitheater. Superficially, it looks that way. However, amphitheaters typically have their lowest levels in the front and build up toward the rear. At Poverty Point, the innermost ridge is the highest one and the outer ridges are lower. Thus, it could not have functioned like an amphitheater.

The density of habitation debris tells us that people lived on the ridges. They also lived on unfinished segments of the ridges during construction. (Although excavations have provided only a tiny window into the occupations of these people, it doesn't appear that their way of life changed much over time—we find the same kinds of artifacts and debris below and within the ridges as we do on top of them.) We don't know why they built the ridges, but having their living surface elevated above the general ground surface would have kept fire pits, house floors, and feet dry after Louisiana deluges.

Archaeologists have looked for the remains of houses on the ridge tops, but we haven't had much success identifying house structures.[14] We find plenty of postmolds, but they don't form nice geometric patterns (like circles or squares) around a smooth, compact surface that would suggest a planned structure with a prepared floor. When groups of postmolds have been discovered, they appear to have been placed at odd angles and spaced irregularly. We do, however, find *daub*, which is earth that was pressed against a framework of sticks to form walls.

Maybe some combination of farming and soil formation has erased any evidence of prepared floors. Maybe the houses were so temporary, so transitory, that they are too difficult to recognize. Maybe they had raised floors. Or maybe we just haven't looked in the right places.

Radiocarbon dates from hearths and other features within and on the ridges indicate that they were built and used over a long period of time, about 1530–1150 BC. We do not yet have enough dates with adequate precision to establish which ridge segments were built first or which were built last. That is one research problem I hope to address in the coming years.

The innermost ridge and the eastern edge of Macon Ridge define a 43-acre flat area that we call the plaza. At many sites, central plazas are relatively uninformative places for archaeologists to work. Although we think of plazas as public spaces that may have been used for social gatherings, they were typically kept clean of artifacts and so there is little evidence of what kinds of activities went on there. Sometimes remains of a central post or two are found, but the accepted wisdom is that there is little of archaeological interest in plazas.

At Poverty Point, however, the plaza is part of the constructed landscape. As archaeologist Debbie Woodiel once wrote: "I think that, because the plaza area is flat today, we tend to think that it was originally flat. It was not. It was an undulating surface."[15] We know that a lot of dirt was brought in to raise and level the area. In fact, it is more like a huge earthwork that you don't realize is an earthwork because it doesn't project above the ground surface.

There aren't many artifacts in the plaza compared to other parts of the site. In fact, of the 43,000 or so cataloged artifacts that were picked up from the plowed surface over some thirty years (before Poverty Point was purchased by the state of Louisiana) by local enthusiast Carl Alexander and subsequently donated to the park, none were from the plaza. A few patches of midden have been located by excavation in the plaza area, but they may be from the earliest occupations of the site, before the plaza was constructed.

7 CIRCLES

Jenny

From 2006 to 2011 geophysicists studied the plaza by carrying specialized equipment over the ground to measure differences in the magnetic field. Images of large circles were obtained, which were eventually discovered to be the remains of structures formed by posts set into the ground during Poverty Point times. There are thirty circles of various diameters at Poverty Point, some built only inches away from previous ones, as if the posts were erected, removed sometime later, moved a slight distance, then rebuilt.

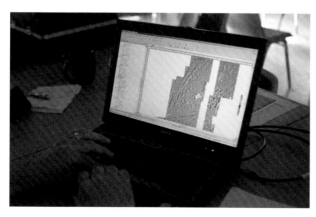

Processing magnetic gradiometry data from Poverty Point's plaza.

Two of the circles are now marked by barrels that were placed to identify where the structures stood during Poverty Point times.

I stand near the largest one and look up at the empty sky and field around me and imagine walls, an open roof, and a dirt floor. I don't know if such an image is accurate, but for me it's more accurate than the emptiness that is here now. There's enough room for a large gathering of people, hundreds of people, coming together for what, again, I can only imagine.

A circle in the plaza.

A large circle in the plaza.

Diana

Archaeologists Mike Hargrave and Berle Clay use specialized instruments to study the subsurface of archaeological sites. It's what we call geophysical survey. At Poverty Point, they have been using a magnetic gradiometer to record very slight changes in the magnetic field as they walk across the site. Tiny magnetic fluctuations due to different kinds of soil, heated features like hearths or earth ovens, Poverty Point Objects, and artifacts of magnetite or other kinds of iron-rich stones are detected. They walk in a systematic way, on a grid, which allows them to make maps showing where these magnetic variations, called anomalies, are located.

Working in the plaza, they began to find rings or circles, the smallest about 60 feet, and the largest about 190 feet, in diameter.[16] Some of them were more magnetic than the average soil, and some were less so. Some looked like solid lines and others looked like follow-the-dots. There are about thirty of these circles, not all of them complete, but all in the southern half of the plaza.

From the gradiometer maps it is impossible to know what the magnetic anomalies indicate or how deeply they are buried. To better understand the anomalies, archaeologist Rinita Dalan pulled soil cores from some of them and used a special instrument, a magnetic susceptibility probe, to measure magnetic properties of the soil at different depths down the hole.[17] She found that some of the magnetic anomalies were buried beneath 2–3 feet or more of artificial fill dirt (added during Poverty Point times to raise the level of the plaza). Soil development within that fill was obvious, indicating the buried anomalies were old enough to be Poverty Point phenomena. To know what caused the circles, though, we would have to dig.

In the summer of 2009, archaeologists Evan Peacock and Janet Rafferty, from Mississippi State University, and I organized a field school, where students came to learn how to excavate and perform other archaeological tasks for college credit. We opened some test units—1-by-1-meter square holes in which the soil was carefully excavated in 10-centimeter levels—to examine some of the anomalies,

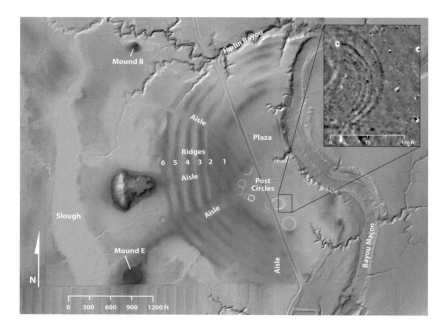

Location of post circles in the plaza; inset is a segment of a geophysical survey map showing a series of ring-shaped magnetic anomalies. LiDAR data courtesy of FEMA and the state of Louisiana, and distributed by "Atlas: The Louisiana Statewide GIS," LSU CADGIS Research Laboratory, Baton Rouge, Louisiana. Geophysical survey image courtesy of Michael Hargrave and Berle Clay.

Archaeologist Michael Hargrave using a magnetic gradiometer to collect geophysical data in the plaza. Photo by Diana Greenlee.

and discovered several postholes.[*] These were cylindrical pits that once contained wooden posts, but, in contrast to postmolds, the posts had not been allowed to rot in place, staining the soil and allowing dirt to gradually wash into the hole; instead, the posts had been removed and the holes were filled with dirt that was different from the natural soil. The different fill is why the postholes were so easily detected magnetically, and why we were able to see them in our excavations.

The postholes we found were round, up to 2 feet in diameter, mostly straight-sided, flat-bottomed, and deep, extending as much as 7 feet below the current ground surface.[**] Sometimes the top of the posthole was larger in diameter than

[*]This was not the first time that postholes had been found in the plaza. In the 1970s, William Haag (1990) excavated two areas in the western plaza while testing for possible placement of the visitors' center. He found many postholes of varying dimensions, including some that extended nine feet below the ground surface, but he didn't have the benefit of geophysical imaging over a large area and so he was not able to recognize any patterning in the placement of the posts.

[**]Even though the bottoms of these postholes were 7 feet down, this doesn't mean they were originally that deep—when the people of Poverty Point added fill to raise the level of the plaza, they placed soil over the abandoned and filled postholes.

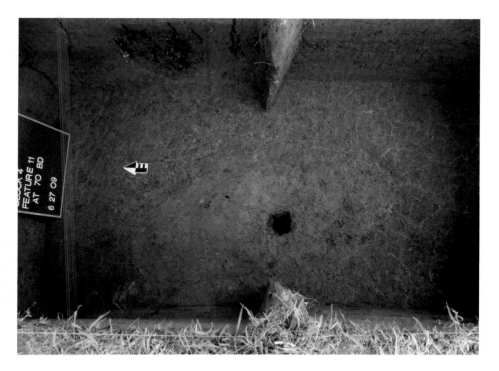

Two adjacent test units placed over a magnetic anomaly in the plaza. The oblong gray area is a posthole at 2.3 feet below ground surface, filled with a different material from the surrounding reddish brown natural soil. The dark spot in the center of the posthole fill is where a soil core had been extracted to confirm our position over an anomaly. Photo by Diana Greenlee.

the bottom, perhaps to facilitate placement of the post. We found that some of the posts had been moved slightly and reset, not once but twice. And some of them overlapped or were so close together that it is doubtful they held posts at the same time.

We didn't excavate a complete circle, or even a significant arc of one. So, there is a lot we don't know about the circles. We don't know how many different kinds of post circles are represented. We don't know how high the posts were. We don't know if there were walls between the posts. We don't know if they had roofs. We don't know what, if anything, they did inside the circles. We don't know how many post circles were visible in the plaza at any one time. Someday, I hope to excavate a larger area of the plaza circles so that we can find answers to these questions.

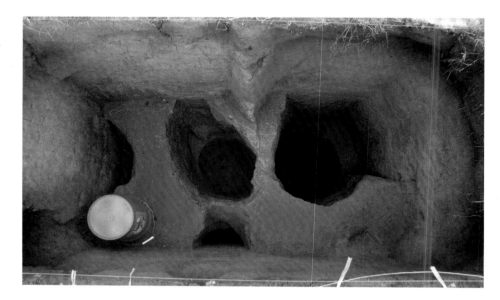

Two adjacent test units placed over another magnetic anomaly in the plaza. The fill for all but one posthole has already been excavated. Two complete postholes and four partial ones were identified in this excavation block. Photo by Diana Greenlee.

Radiocarbon dates on charcoal from the postholes show about the same age range as the ridges, or perhaps the postholes are a little younger (1450–1150 BC). Where the innermost ridge intersects a post circle in the south end of the plaza, we suspect that the circle may be older, mostly because the ridge would have been an impediment to constructing the post circle. Radiocarbon dates from features in the fill on top of the circles show about the same range as the postholes, or perhaps a slightly later (1420–1130 BC) range. So, as near as we can tell, building the ridge system, setting and dismantling the post circles, and raising/leveling the plaza all happened over roughly the same period of time.

8 MOUND A

Jenny

Walking northwest across the plaza, tripod resting on my shoulder, I become lost in thought and begin to daydream. I forget about the weight of my camera bag and the tasks waiting for me at home. I swim in reveries, both new and ancient, until they all run together.

I cross over the tram road and head into the woods on the western ridges, my head down, my mind adrift. I glance up to get my bearings and come suddenly upon it—the massive earthwork that is Mound A. I had forgotten where I was, forgotten I was approaching it, and I am startled. Then overwhelmed. Then humbled. It rises over seventy feet above the surrounding flat Louisiana land and I crane my neck to see its summit. It is by far the largest earthwork at Poverty Point and stands majestically, powerfully, above the entire complex.

I have spent many afternoons wandering around its base, contemplating its meaning and imagining it as it must have been when first constructed. Was it built in the shape of a bird as some people suggest, flying west, wings stretched north and south? How many workers were needed to build it? And along with those builders, was there a designer, an engineer, a foreman?

Once on the summit I wonder who would have been allowed up here in ancient times. Everyone? Only the elite? And what would they think of me now as I try to find them, try to envision their city stretched below me? I mentally cut down the trees in the plaza, build houses on the ridges, replace the barrel circles with wooden posts and add people, hundreds of them, maybe thousands. I sniff the air

Mound A.

Mound A with a person barely visible on the top of the mound, at the summit of the "bird's wings," and another ascending the ramp from the "tail." A third person is seen in the foreground, walking south of the mound.

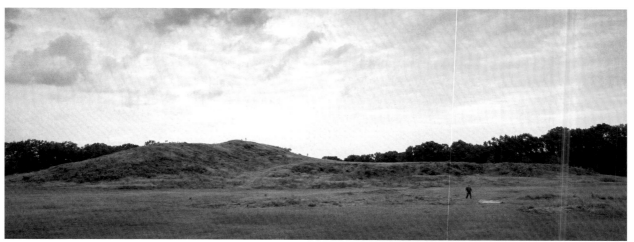

for smoke and fish scales and listen for the thud of *celts* pounding against wood. In brief moments it comes to life, loud and bustling, shining and clear and full, before it slips through my imagination and reality returns.

I know Mound A was significant, not just to the people who lived near it, but to everyone who visited the site. It must have inspired awe in all who stood below it. Built along the same north-south axis that connects Mound B and Mound E and

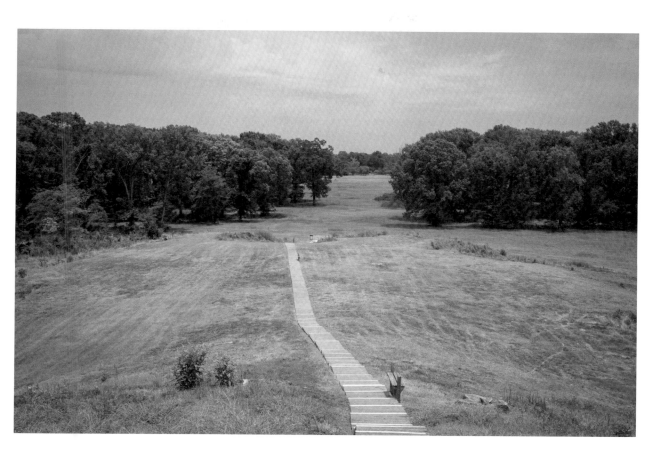

Looking east across the plaza from the top of Mound A.

the Lower Jackson Mound, its placement surely had meaning, unknown to us, but important to them.

I lean back on the modern wooden platform on its top and stare up at the sky. Insects buzz nearby just as they did long ago. I watch as a dragonfly lands on the railing, pauses for a second, then lifts off again. The afternoon sun sinks closer to the tree line, and I know I must head back home soon. I pause and think how wondrous it must have been for the dwellers of this ancient city to know that this amazing place *was* home.

Looking south from the top of Mound A, with Mound E in the mid-ground and the Lower Jackson Mound barely visible in the distance, roughly two miles away.

Mound A.

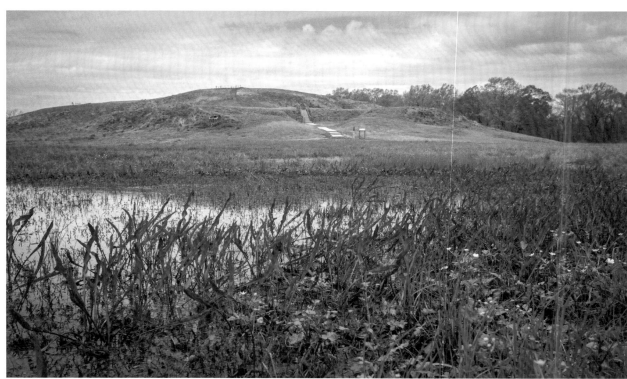

Diana

Mound A is a huge earthwork that looks like a small mountain. Consider this: Gerard Fowke—a distinguished archaeologist who had worked for both the Smithsonian Institution and the American Museum of Natural History, and who had visited and mapped and dug into hundreds, probably thousands, of mounds while working on the problem of the "Mound Builders"*—visited Poverty Point in 1926 or '27. He stated: "They [Mound A and the nearby Motley Mound] were found to be of natural origin, solitary outliers, the only ones for many miles in any direction, of the geological formations found in the bluffs to the east and the west of the [Mississippi] river; islands left by the drainage which cut the present river valley. Their appearance would easily deceive anyone who was not somewhat familiar with such deposits."[18] If somebody as knowledgeable and experienced as Gerard Fowke could mistake the mound for a naturally occurring geologic formation, Mound A must be an impressive piece of work.

Here are some statistics: Mound A is 72 feet tall at its apex with an adjacent 30-foot-tall platform, 710 feet long (east to west), 660 feet wide (north to south). By volume, it's about 8.4 million cubic feet (almost 312,000 cubic yards) of dirt. Take a standard American football field and make it 146 feet tall. It's that much dirt.

At an average weight of 1.25 U.S. tons per cubic yard, that's almost 390,000 tons of dirt, which, if you have a standard dump truck, is almost 15,000 loads. If you are a Native American with a basket holding about 50 pounds of dirt, that's about 15.5 million loads.

*Many Euroamerican settlers did not believe that Native Americans, who were seen as primitive and uncivilized, were responsible for the thousands of mounds located throughout the eastern United States. A mythical race of sophisticated "Mound Builders" was thought to have built the earthworks prior to their displacement by ancestors of historic Native American tribes (Silverberg 1989). It wasn't until the late nineteenth century that archaeologists demonstrated that the ancestors of modern Native American tribes did build the earthworks.

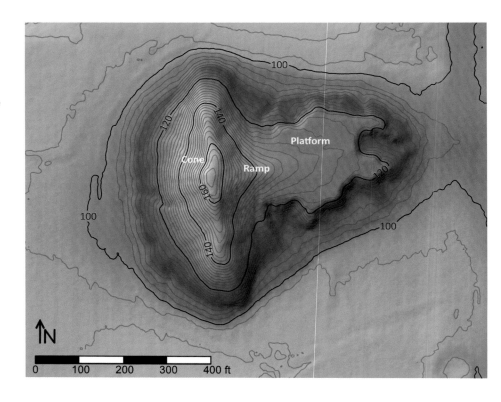

LiDAR topographic map of Mound A. LiDAR data courtesy of FEMA and the state of Louisiana, and distributed by "Atlas: The Louisiana Statewide GIS," LSU CADGIS Research Laboratory, Baton Rouge, Louisiana.

Mound A was the largest earthwork of its time in North America. It surpassed, by orders of magnitude, anything that came before, and it remained much larger than anything that followed for another 2,200 years or so. The only mound to exceed it in size, Monks Mound at Cahokia in Illinois, was built by people with an agricultural economy.* Large-scale mound building, as with other cultural elaborations, is more surprising among hunter-gatherers than among agriculturalists. Farmers tended to have higher populations and greater year-to-year fluctuations in resource productivity—bet-hedging would have been more critical to their long-term success by maintaining populations at a level below carrying capacity.

*Emerald Mound, located near Natchez, Mississippi, is also larger than Mound A in total volume, but its construction took advantage of a natural ridge and thus it is not a wholly artificial construction. Like Monks Mound, it was built by agriculturalists over 2,000 years after Poverty Point's Mound A.

The shape of Mound A has captured the imagination of many people. Some see a bird flying westward, toward the setting sun (hence, the commonly used name Bird Effigy Mound or Bird Mound). A neurologist sees a human skull. Me? I see a mushroom, sliced in half lengthwise. Of those perceptions, the bird may make the most sense, if only because birds are important within the iconography of Native Americans past and present of the southeastern United States. There is no way to know, though, if that's what the builders of Mound A intended. We can only speculate.

Archaeologists have looked unsuccessfully for evidence of buildings on top of the platform and for burials in the mound. Only a few artifacts have been found within the fill, and these don't appear to be purposeful placements. They are more likely to have been accidental inclusions within the soil as it was loaded into baskets and then dumped.

To me, one of the most impressive things about Mound A, besides its sheer size, is the dirt used to build the platform. Dirt may be dirt to some people, but in the Mound A platform it is art. Individual basketloads contained different kinds of soil, from

The interior of the Mound A platform, showing the diversity of soils used in its construction. Photo (No. c76/608) courtesy of the Louisiana Division of Archaeology, Department of Culture, Recreation, and Tourism; photo by Debbie Woodiel.

different depths and different places on the natural landscape at Poverty Point. As William Haag found in his 1976 excavation into Mound A's platform, there is a mosaic of light grays, oranges, yellowish browns, reddish browns, and blacks, all mixed together. This was a break from the sameness, the homogeneity, of dirt used to build the earlier mounds. It was, perhaps, a new recipe for building a mound meant to impress.

Archaeologists Anthony Ortmann and Tristram Kidder have used soil cores and excavation to study how and when Mound A was built.[19] They identified three different construction stages: (1) the tall conical part on the west (the "bird's wings"); (2) the broad platform part on the east (the "bird's tail"); and (3)

a ramp that connects the two, facilitating access to the very top of the mound. Importantly, they did not find evidence in their cores or excavation for a pause in construction; there were no surfaces with accumulated debris, no indications of vegetation taking hold or soil mixing by earthworms or bugs, no clay particles washed by rainfall into cracks in the soil. They argue that, once the Poverty Point people started working on Mound A, they didn't stop. They calculate that it is possible, with enough people and enough preparation, that it could have been a ninety-day project. Why ninety days? Looking back through historic rainfall records, Ortmann and Kidder found the longest period of time without rainfall in northeast Louisiana was about thirty days. Thirty days to build Mound A sounded improbable, so to be conservative they tripled it.

Clearly, it didn't take hundreds of years to build Mound A, as archaeologists once thought. It didn't even take decades. I admit that I am skeptical that Mound A is a ninety-day wonder, but I don't have evidence to disprove it. It just seems unlikely, especially when you think about 15.5 million basketloads of dirt, loosened with digging sticks, loaded into baskets and bags, in some cases carefully mixed, carried, dumped, and packed.* That, along with all of the other tasks that daily life requires, like gathering and preparing food, repairing tools and maintaining houses, and taking care of children. I think that additional research, looking at more or different samples, could shed light on the issue. This is how science works and knowledge advances. You have a question, you collect the data necessary to answer the question, you conduct your tests, and, if not disproven, you advance your explanation, which is subject to further testing and refinement. Often, answering one question raises other questions.

Radiocarbon dates derived from charred botanical remains found directly under Mound A indicate that its construction began sometime after 1430 BC. Until recently, it was thought to be the last Poverty Point–aged earthwork built here, but the discovery of another mound has caused us to reconsider that idea.

*The people of Poverty Point did not have metal tools, like shovels and picks, nor did they have draft animals or wheeled carts to ease the burden.

9 MOUND C

Jenny

Mound C is the only Poverty Point mound with a view of the bayou.

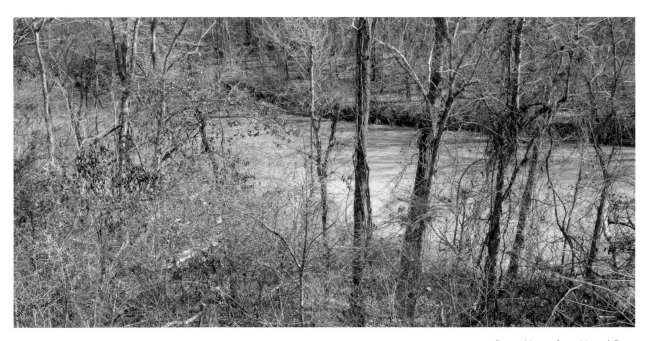

Bayou Maçon from Mound C.

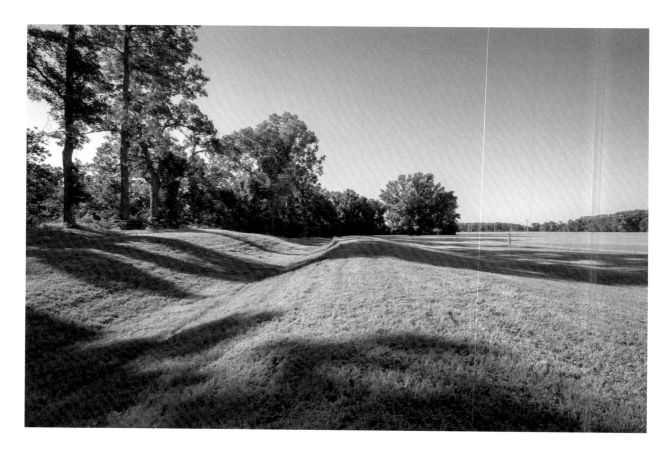

Mound C.

It is also the only mound built within the plaza.

And it is the only mound I have stood inside as it was being excavated, when its interior was exposed.

The interior walls of Mound C during an excavation.

I stood before thin layers of soil that varied in color and texture. Looking directly into its construction made it impossible for me not to wonder why so many thin layers, why the different colors? What was their purpose or meaning? The layers also contained small bits of debris such as charcoal and cooking ball fragments as well as postholes. Were people living on this mound, holding ceremonies or other activities? Archaeologists have dated the mound to the Poverty Point era but have been unable to pinpoint its exact date within that time frame. It seems that the more that is learned about Mound C, the more mysterious it becomes.

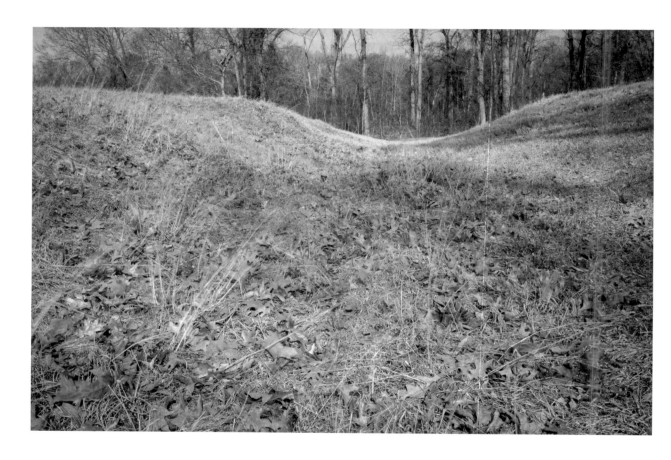

Mound C.

The middle of Mound C was damaged significantly by a road that formed in the 1840s from wagons traveling across it en route to the nearby town of Floyd. It carved the mound in two, leaving a trench as a divider.

Diana

Mound C is not superficially impressive compared to other earthworks at the site. Today it measures about 260 feet long by 80 feet wide, but some of its original width has probably been lost to Bayou Maçon. It appears to be about six feet tall, but its base actually extends about two feet below the adjacent plaza surface. Because a Historic Era* roadway is etched lengthwise across its center, we will never know its original shape, but we suspect that it was domed or loaf-shaped.

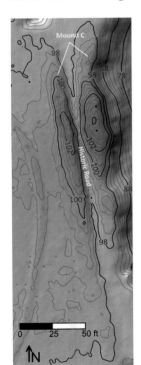

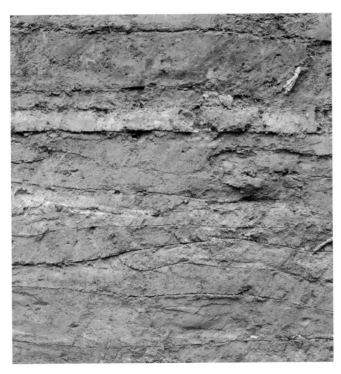

LiDAR topographic map of Mound C. LiDAR data courtesy of FEMA and the state of Louisiana, and distributed by "Atlas: The Louisiana Statewide GIS," LSU CADGIS Research Laboratory, Baton Rouge, Louisiana.

The interior of Mound C, showing a series of thin surfaces of different colored and textured soils.

*By Historic Era, archaeologists mean the time period of written records; in northeast Louisiana, that would be since Europeans arrived 300 or so years ago.

Excavations by Jon Gibson and Anthony Ortmann showed that the internal structure of Mound C is very different from that of the other mounds at Poverty Point. Within this mound is a series of thin, prepared surfaces, or floors, made of different colors and textures of earth. Some of these surfaces have features like hearths and postmolds on them, evidence of trampling, and artifacts that suggest people were living or carrying out special activities on this mound. The final stage of mound construction involved placing a thick cap of silt loam over the entire structure.

Ortmann collected soil samples from the surfaces of the prepared floors during his excavation of Mound C in 2011. He is currently analyzing these samples for what archaeologists call "microartifacts." These are microscopic artifacts, such as tiny pieces of stone left from making tools or other objects, little fragments of Poverty Point Objects, and bits of charred wood. Importantly, they are all small enough to remain even if the floors were cleaned. From them, we can tell what kinds of activities occurred on those surfaces, even if the floors were swept afterward. These kinds of analyses are very time consuming, and I am eagerly waiting to learn what Ortmann discovers about the floors of Mound C.

The age of Mound C is problematic.[20] There are three radiocarbon dates on charcoal, one from midden directly under the mound and two from within the mound. They range over 1770–1220 BC, all consistent with a Poverty Point construction. But they are out of sequence from top to bottom. The middle date is younger than the uppermost date. This means that at least one date does not accurately reflect the age of the mound deposit, but we don't know which one or ones are wrong. One of the goals of the recent excavation by Ortmann is to resolve the issue about the timing of Mound C's construction.

Like Mound E, there is some confusion about the common name for Mound C. This mound is also known as Dunbar Mound. Some people think the name pays homage to William Dunbar, of the Dunbar-Hunter Expedition commissioned by President Thomas Jefferson to explore the Ouachita River in Louisiana and Arkansas. Actually, it refers to a turtle, captured by an archaeological field school in 1983 and named Dunbar (after a character in *Catch-22*), who apparently had a propensity for escaping and thereby avoided his fate as turtle soup.[21]

10 MOUND F

Jenny

Mound F has a haunted and ghostly feel to it. It lies across a gully, deep in the woods, covered in fallen limbs and decades of decaying leaves. Visiting it feels like stepping back in time, being able to see a Poverty Point mound before the encroachment of chain saws and guided tours. Most of its secrets still lie buried beneath the tangled surface, guarded by thorns and a profusion of poison ivy. It is a box found long after the attic was thought to be emptied, covered in cobwebs and a thick layer of neglect. I stand before it expectantly, impatiently, as the box is slowly, slowly opened.

Mound F.

Diana

Until August 2013, we thought that all of the Poverty Point earthworks had been identified. Numerous archaeologists had studied the site since C. B. Moore in 1913, and no additional mounds had been discovered. In 2011, I walked to the wooded far-northeastern corner of the park with our GPS receiver to acquire coordinates for a map. That area is closed to the public, and park personnel rarely go that way as there are deep gullies, brambles, and lots of poison ivy to discourage the casual visitor. On my way to the corner I took the most direct route along the fence line, but on my way back to the office, I decided to follow the bayous. That is where I discovered what looked like a small mound on the eastern edge of Macon Ridge. It was about 80 by 100 feet at its base and about 5 feet tall. But could it really be a new mound, apparently undiscovered and unmentioned in the voluminous literature about Poverty Point?

Other obligations did not allow me to evaluate our possible new mound for about eighteen months. I could only stare at the *LiDAR* map and wonder. Finally, in August 2013, I had a small window of time to conduct some preliminary tests of this possible mound, and I contacted soil scientist Thurman Allen to help me obtain some soil cores. We extracted four cores, which revealed it to be an artificial construction. It was indeed a new mound—the first one discovered at Poverty Point in one hundred years.

A radiocarbon date on charred wood from its base indicates that mound construction began sometime after 1280 BC, which means it may have been the last Late Archaic mound built at Poverty Point. The degree of soil development within the mound fill is consistent with that assessment.

Mound F looks like it is sitting on the southeastern end of a small natural ridge. It is much more impressive from the lowlands to the east than it is from the west. Research to further examine the mound using different geophysical and dating methods, along with targeted excavations, is ongoing.

LiDAR topographic map of Mound F. LiDAR data courtesy of FEMA and the state of Louisiana, and distributed by "Atlas: The Louisiana Statewide GIS," LSU CADGIS Research Laboratory, Baton Rouge, Louisiana.

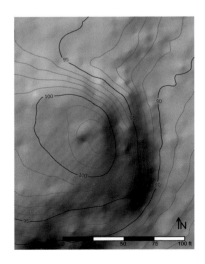

11 THE DOCK

Jenny

Depending on vegetation and time of year, the expansive city of Poverty Point may have been seen overland from as many as twelve miles away. But the most likely way people would have first arrived there would have been by boat from Bayou Maçon.

There is a place at the site that archaeologists call the dock. It is a gentle slope up from the water's edge, now covered in grass and wildflowers during the warmer seasons. Excavations have shown that the upper crest of the dock was artificially enhanced and made more prominent by the builders of Poverty Point.

To those arriving from the water, the bustling city would have been invisible. And as they ascended the slope, it would have remained so. Visitors would have walked up and up the slope and only when nearly at the crest of the ridge would the earthworks have appeared, suddenly, even now taking my breath away with no people or structures to greet me. And when finally at the top, turning and looking back down at the water, these visitors would find that the bayou had disappeared from view.

There was a disconnect, a moment of visual silence when arriving or departing the site from the bayou. An elongated pause before the dazzling wonder of the city was revealed. Or left behind.

Looking up from the base of the dock. The Poverty Point earthworks lie over the top of the ridge.

Diana

We use GIS (geographic information systems) to help us understand the visibility of the earthworks on the landscape and how they relate to one another geographically. Archaeologists Doug Comer and Miles Wimbrow used LiDAR maps to determine, for example, how far away one could be and still see Mound A, assuming excellent vision and nonintrusive vegetation. Given their assumptions, the curvature of the earth and the height of the mound would have been the limiting factors, and thus it would be visible for nearly 12 miles. There is no way to know for sure, but trees probably would have obscured the mound's visibility over that great of a distance.

The river system would have been the most efficient way to travel during Poverty Point times, and we thought that Mound A would be like a beacon, beckoning to visitors as they approached this great site. However, Comer and Wimbrow determined that Mound A would not have been visible as one traveled toward the site on Bayou Maçon. The bayou hugs Macon Ridge so closely over most of its path that the ridge effectively blocks any view of Mound A. Smoke from hearths and earth ovens, the noises of life, and watercraft beached at the dock may have been the major clues that the travelers had arrived at Poverty Point.

Although we know that the top of the dock, where it meets the plaza, was artificially enhanced, we don't know if the gradual slope down to the bayou was a natural feature or if it was part of the engineered landscape of Poverty Point. It certainly contrasts with the steep bluff that characterizes the edge of Macon Ridge both north and south of the site. If the dock was natural, that could have played a role in determining to settle at that spot. Creating it, however, would not have been outside the capabilities of these earthmovers. Excavations have revealed postmolds, pits, hearths, and artifacts still preserved on the upper part of the slope, and geophysical survey is planned to investigate other areas of the dock so that we can better understand this important point of access to the site.

Comer and Wimbrow also examined the changing view as individuals move upslope on the dock from the bayou toward the plaza. They called it a moment of drama when "the monuments at Poverty Point become visible, suddenly and massively," and they noted that similar kinds of awe-inspiring moments are known for other famous archaeological sites, such as Petra (Jordan), Machu Picchu (Peru), and Brú na Bóinne (Ireland).[22]

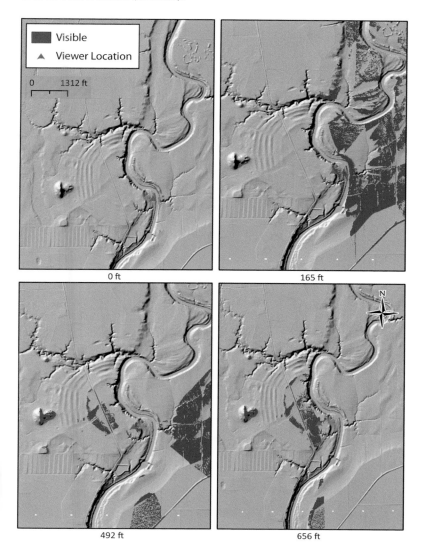

Model of what a visitor to Poverty Point can see as he or she walks up the dock from Bayou Maçon to the plaza. The red arrow indicates the visitor's location and the blue shading indicates what part of the landscape is visible from that position. Initially, the earthworks are entirely hidden. Once the ridge is crested, the site comes into view and, after a few more steps, the terrain traveled is no longer visible. Image courtesy of Douglas Comer.

III LIFE AT POVERTY POINT

Pawpaw found at Poverty Point.

12 THE MACON RIDGE

Jenny

As I walk the site, I am reminded that some of these same kinds of trees and plants were here thousands of years ago. I stand beneath the pawpaw trees and search the ground for fruit, picking my way through the poison ivy and cringing at the tall grass and the chiggers I know are there. I realize I would make a terrible forager. But the Poverty Point people lived their entire lives on what they could find on the ground, fish from the water, or take down with a projectile point and an *atlatl*. While the people who built Stonehenge and the Pyramids and the Cahokia Mounds in Illinois had agriculture, the people of Poverty Point did not. It is the largest city built anywhere in the world by hunter-fisher-gatherers.

I hold my lowly pawpaw and wonder how many of these it would take to make a meal for the hundreds (or thousands) of people who lived here. How many baskets of fruit? Pounds of fish? Day in, day out? The rich resources of the high, dry Macon Ridge and the adjacent lowland swamp would have provided food year-round. And the people would have known how to find it, where to look, what to expect season after season. My small, bruised pawpaw reminds me of just how distant from the land I have become.

Diana

Poverty Point is situated on an elevated landform, Macon Ridge, that forms the western edge of the Mississippi River valley in northeast Louisiana. The site is about 22–30 feet above the adjacent floodplain. Being located at a higher elevation was important because, without the artificial levees we have today, the river would have seasonally flooded the valley. Poverty Point stayed dry during the great flood of 1927 and the even greater flood of 1828; it is unlikely that floodwaters ever breached the top of Macon Ridge here.[1]

Not only was this an excellent location for staying high and dry, but it provided easy access to both drier upland and wetter bottomland environments. Proximity to different habitats ensured relative stability in the availability of food and other raw materials. A bad year for one kind of resource was likely to be offset by a good year for another one.

Plant remains (bits of charred wood, nutshell and seeds, pollen, and *phytoliths*) tell us about the surrounding environment and the kinds of plants that the people of Poverty Point exploited as food and fuel and for tools, baskets, houses, and other structures.

Elizabeth Scharf examined tiny pollen grains and bits of charred wood embedded in the sediments of her cores from the slough in order to study the history of vegetation at Poverty Point.[2] She established that the environment around the site was naturally open, with meadows, wetlands, patches of upland woods, and floodplain forests. Indeed, there were fewer trees in the area during Poverty Point times than there are now, even though much of the land is currently cleared for agriculture.

Edible nuts, fruits, and seeds, including hickory nuts and acorns, muscadine grapes, pawpaws, persimmon, and goosefoot, were available in the area. Seeds and

Pollen grain from a sweetgum tree. Photo by Elizabeth Scharf.

Pollen grain from a pine tree. Photo by Elizabeth Scharf.

fragments of nutshell were charred and preserved, so we know that the people of Poverty Point took advantage of those resources.

Linda Scott Cummings examined pollen and starches in sediments beneath the ridges and associated with fired-earth Poverty Point Objects.[3] She found evidence for aquatic plants, such as water lily and lotus, on the objects and concluded that tubers from those plants were likely harvested and roasted in earth ovens.

Charred remains, impressions in daub, and cane casts (earth pushed inside a hollow cane segment and fired) provide evidence that cane was an important raw material for tools, baskets, and matting, as well as for construction and fuel. Charred wood fragments from red oak, white oak, bald cypress, eastern red cedar, pine, and sweetgum, among others, tell us that a variety of different wood types were also used as fuel and probably for construction.[4] No wooden tools have been preserved.

13 HUNTING AND FISHING

Jenny

I rose early one October morning and drove the hour to Poverty Point in darkness. I had received permission to arrive there before daybreak and hoped to photograph the sun rising over Bayou Maçon and illuminating the mounds with early morning light. I parked near Mound A and began walking toward the center of the plaza. Alone, in the barest of light, I carefully picked my way across the uneven ground, mindful of the armadillo holes hidden below the grass. As I passed the base of the mound I heard noises, muffled, something breathing, then heavy thuds, and the rustling of leaves. I looked toward the woods and could see dim silhouettes, the flick of white tails the only identifying markers. I watched for a few brief seconds as a dozen deer moved between the trees and were absorbed by the darkness. I stood like a statue, listening as the sound of their movements faded away with them.

On another occasion, in the middle of the afternoon, I was circling the base of Mound A when a doe came thundering down the slope. She ran directly in front of me before crashing into the underbrush of the slough and disappearing.

I've seen their tracks in the mud and touched the cuts left by their hooves. They are my only photographic evidence that the deer are, indeed, real.

The wild game would have been here during Poverty Point times also, drawn to the region for the same reasons the people were—the abundant food sources. The ancient bones of these animals have been found on the ground's surface and dredged from the nearby bayou.

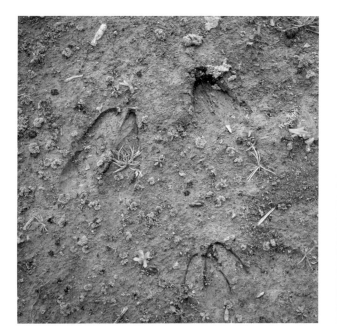
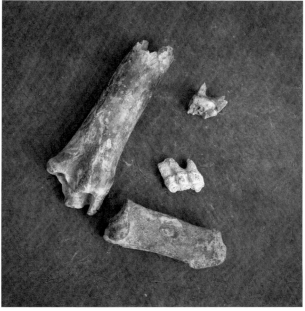

Deer tracks near Mound A.

Deer bones found at Poverty Point.

Diana

The acidic soils at Poverty Point are not kind to bones. They tend to dissolve and leach away in environments like we have here. In a recent examination of the totality of bones and bone fragments in our collections (nearly 15,000 pieces), only about 6 percent can be identified. The remaining bones are too small to show any of the distinctive anatomical characteristics that are needed to determine what species, genus, or even family of animal is represented.

About half of the identifiable bones were picked up from the surface, recovered from the plow zone (the upper foot or so of soil that has been disturbed by plowing), or removed from sediments dredged from the bottom of Bayou Maçon. They are from what archaeologists consider questionable *context*, meaning that we

can't be sure how old they are or how they came to be there. Almost half of these bones are fish. Other animals include deer, raccoon, opossum, beaver, alligator, and duck (along with horse, pig, and cow that were brought to this continent by Europeans). In a general sense, they reflect a diverse local environment, with both terrestrial and aquatic habitats.

The other half of the identifiable bones are from excavations. They tell us what people ate and what the environment was like during Poverty Point times. Most are tiny pieces, and they frequently have been burned. The vast majority of these bones (about 88 percent) are fish, with lesser counts of deer, squirrel, raccoon, turtle, and dog/wolf family. Poor preservation notwithstanding, fish appear to have been a critical resource. This is true at other sites of the same time period. With oxbow lakes, small streams, backwater sloughs, and bayous on the nearby floodplain, aquatic animals such as fish, turtles, waterfowl, molluscs, and frogs would have been a plentiful and predictable resource.

The people of Poverty Point did not have domesticated animals, with the likely exception of dogs. We know from other sites of similar age that domesticated dogs were present in North America, but we have not found bones in our collections that can be certainly attributed to them. This is probably because of the fragmented nature of our faunal remains and the difficulty in distinguishing dogs from coyotes and wolves by their bones (this requires nearly complete skulls or mandibles).

14 LONG-DISTANCE TRADE

Jenny

There's no rock at Poverty Point. I asked. Repeatedly. We were photographing artifacts, and I would pick up a stone tool and ask, so, was this made from rock found here? The answer was always no, even when I picked up something else fifteen minutes later and asked the same question again.

The closest rock was in gravels of the Bastrop Hills and Mississippi River terraces roughly 25–30 miles away. The Poverty Point people utilized those sources, but they also had stone from places as far away as Iowa and Georgia. How did it get here? Did the Poverty Point people go to those distant lands and bring it back? Did the people from those faraway places bring it to Poverty Point?

To transport the rock they would have had to travel over land or through an intricate system of waterways with frequent portages. But the rock is definitely here, over 78 tons of it.

The sound of stone striking stone carries across the plaza, even now, as tool-making demonstrations go on for the visitors. The pieces retain the warmth of their maker's hands. They are passed off to me, and I feel the heat from moments or thousands of years ago.

The tons of rock at Poverty Point arrived here across ancient trade routes many thought couldn't have existed so long ago. But those routes did exist. I photograph a steatite bowl found at Poverty Point that was made in northwest Georgia and know that they did.

Steatite bowl. From the collection of the Louisiana State Exhibit Museum, Shreveport.

Diana

One of the trade-offs for living on Macon Ridge was that there was no source of stone for cooking or toolmaking at the site, unless people wanted to dig down 26–50 feet for gravel up to 3 inches in size.[5] The closest accessible sources of stone, outcrops of what we call "local" gravel, were about 25–30 miles away. The people of Poverty Point were not restricted to local sources, however.

Stone from some places, certainly not every place, is distinctive in terms of its appearance or chemistry. Archaeologists have been able to use those distinctive

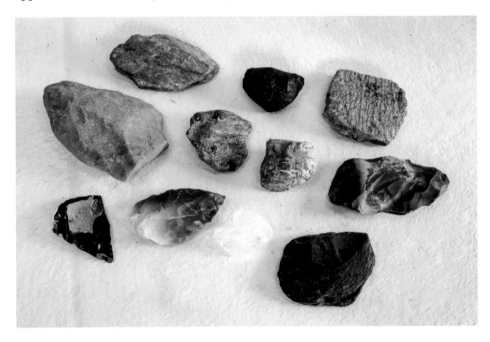

Some of the different stone raw materials brought to Poverty Point.

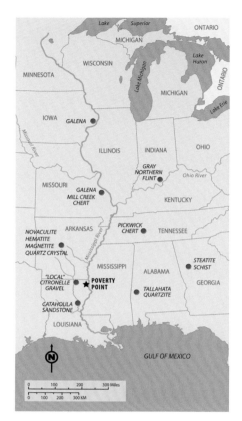

Map showing the geological sources of some different raw materials found at Poverty Point. Redrawn from Gibson (1994, 130); color added.

traits to determine where some of the stone and ore used at Poverty Point came from.[6] Over the years, some of the identifications have been quite secure, while others are less so. With the exception of the steatite, which came from its source as bowls, the stone did not arrive at Poverty Point in finished form.

Galena, a lead sulphate ore that has a shiny metallic look on its freshly exposed surfaces, came from Iowa and Missouri; Pickwick chert, a stone similar to flint with characteristic gray, red, and yellow bands, came from Tennessee; steatite, also known as soapstone, came from northwestern Georgia. The acquisition of these raw materials from such a large area of the midcontinent is often envisioned as a trade network. The problem is that we don't know what the people of Poverty Point might have exchanged for all of that stone. We don't find artifacts in archaeological sites near the stone sources that look like they might have come from Poverty Point. Did they trade something, like textiles or hides or dried fish, that simply didn't preserve? Or was it something less tangible, like goodwill or promises of marriage?

Maybe the people of Poverty Point traveled on the network of rivers to acquire the stone. Some of the suggested sources are 1,000 or more miles distant. Or, maybe people from those locations brought the materials to Poverty Point. Perhaps it was a tribute offered as part of a pilgrimage to this amazing site. But, then, wouldn't we see at least a few artifacts that look like they came from distant places? For now we can only speculate.

For many cultures, exotic materials are not distributed equally throughout the population and are often reserved for use as special items, such as burial goods. At Poverty Point, it appears as if the imported stone was broadly distributed and used for both utilitarian and ornamental items.

15 POVERTY POINT OBJECTS

Jenny

With no truly local stone available, the inhabitants of Poverty Point made their own "fake rocks," which were used for cooking. Molded from moistened silt loam, they were placed in earth ovens and heated. Once the fire had died, food was placed on the warm Poverty Point Objects (PPOs), covered with dirt, and left to roast or steam.

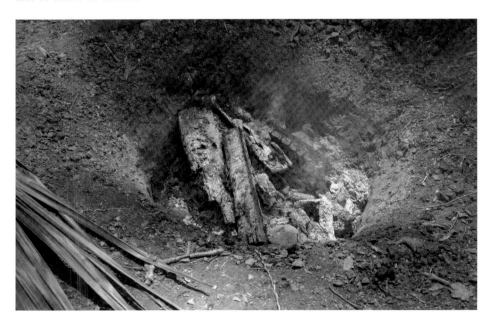

Earth oven with PPOs.

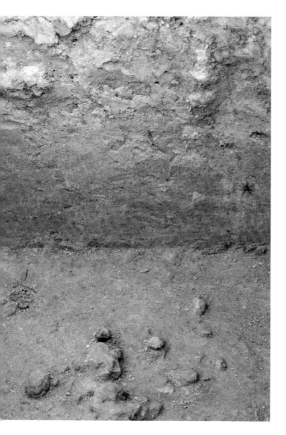

Test unit in the plaza with visible PPOs.

Twisted melon-shaped PPO.

Thousands of these PPOs have been discovered at Poverty Point. They are primarily clustered in the ridges, left behind in places where people lived the domestic parts of their lives. I have seen them trapped in the dirt during excavations, clinging to the sides and bottom of an open pit where they were dropped over 3,000 years before. It is magical to touch them in situ, to reach into the past and watch as they are slowly and painstakingly delivered into the present.

I once borrowed a PPO to show the audience during a TEDx talk I was giving at a locally organized conference in Monroe. I signed it out and brought it home, terrified I would drop it or lose it. I sat in a chair in my backyard and held it in my hand, my fingers falling naturally into grooves made by the fingers that created it.

Cross-grooved PPO.

Diana

These hand-formed fired-earth objects, and fragments thereof, are the most common artifact type at Poverty Point. Indeed, we jokingly describe them as dandruff on the site. Also known as baked clay balls, cooking balls, or PPOs, these ceramic artifacts served as replacements for stone in hot rock cooking, which was the dominant cooking technology of the time. They are found at other sites in stone-poor locations, but not as frequently as at Poverty Point. And they didn't completely replace stone for cooking here, as there is still plenty of heat-damaged, or "fire-cracked," rock.

PPOs are found in several distinctive forms. Explaining why they display the forms they do has been a challenge for archaeologists, and we haven't quite figured

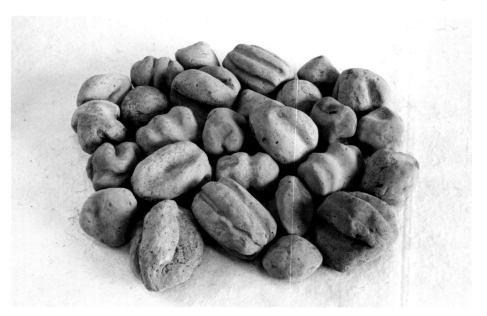

PPOs.

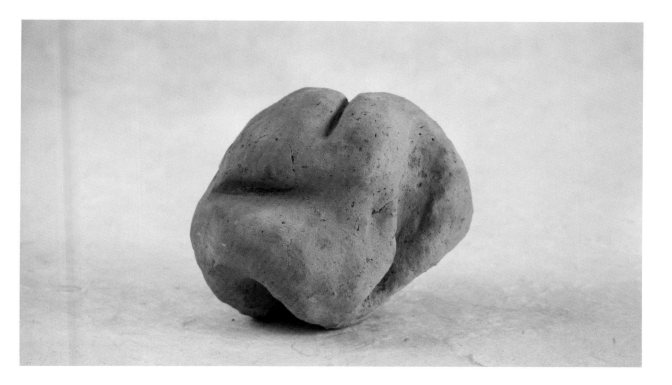

it out yet.[7] Some forms appear to vary in popularity through time and across space, suggesting that the variation may be stylistic. It may also be that the different forms held and radiated heat differently, depending upon their mass, surface area, and placement of grooves, in which case the variation would be functional.

It is primarily the iron in the silt loam soil that gives them their color, but the availability of oxygen when they are heated and cooled determines how the color will be expressed internally and externally. When they were cooled in the presence of air, the outside surface turned a warm orange, but when there was no air, it turned gray.

16 TOOLS

Jenny

I set up my camera and tripod and settle upon a lens from a half-dozen choices. Everything is electronic and if the batteries die, I am done for the day. My bag of gadgets is heavy, and when side by side with the tools of the Poverty Point inhabitants, it feels excessive. I feel excessive.

How were they able to build and sustain such a large city with such simple tools? And how were they able to manufacture them with such precision? The plummets are solid in my hand and smooth with perfectly round holes.

As I photograph a celt, I study the working edge. It is worn down and scarred from the felling of trees for firewood or perhaps by creating the posts used to build the mysterious circles in the plaza.

Though they had many more tools than their predecessors, they still used so few relative to all the ones that get me through a normal day. It's their knowledge of how to get by with so little that fascinates me. How to shovel dirt without a shovel?

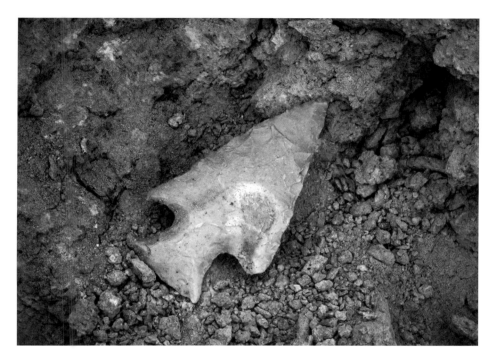

Projectile point.

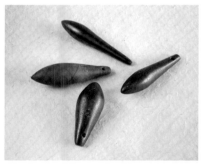

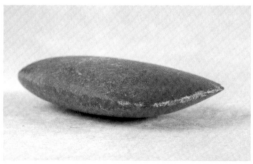

Plummets.

Celt.

Diana

During the Late Archaic period, the time of Poverty Point, there was an explosion in the diversity of stone tools that people made and used compared with the tool kits of the Middle Archaic groups. Also, pottery—the oldest pottery in the Lower Mississippi Valley—has been found at Poverty Point. Only a few bone tools have been recovered, just enough to make us wish (again) that bone preservation were better here. And, right now, we can only imagine what kinds of tools were made of wood that long ago rotted away, leaving no trace.

What most people call "arrowheads" actually functioned as spear points during the Poverty Point era. They are simply too large to have been effective arrow points, and the bow and arrow wasn't adopted in northeastern Louisiana until about AD 700, about 1,800 years after the end of Poverty Point.[8] As with Clovis points, however, it is more accurate to think of these spear points as multi-purpose tools. They show use wear consistent with many different activities, including scraping, cutting, and drilling. Spear points were chipped from many different kinds of chert and are found in a variety of forms.

Projectile points.

Microliths. Clockwise from top: Core, blade, blade, perforator, perforator, perforator.

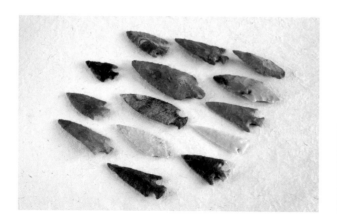

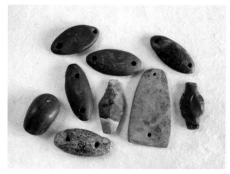

Plummet.

Gorgets and atlatl weights.

Microliths, or small stone tools, are abundant at Poverty Point. They represent an efficient use of the small cobbles available in the "local" chert deposits, because several tools of similar shape with sharp edges could be produced from a single stone. This involved special preparation of the stone, turning it into what we call a core, so that multiple long, thin chips, or blades, could be struck from it. The blades could be used, as is, for cutting or scraping. Perforators are key-shaped microliths that have been thought by some to be tools made from blades, but they may actually be worn-out blades, shaped by their heavy use as scrapers.

Many of the stone tools at Poverty Point don't look like tools at all. They just look like chips or chunks of stone. When we look at the edges with a microscope, though, we can see that they were used to scrape, cut, pierce, engrave, or batter something.

The heavy teardrop-shaped objects called plummets look like modern-day plumb bobs. They often have drilled holes by which they could be suspended, although some have only fine grooves and some have no obvious means of suspension. A few have regular, smooth surfaces that look as if they were turned on a lathe, but they were not; most are rougher than that. Typically made of tough, iron-rich ores like hematite and magnetite, they were initially thought to have served as bola weights (for entangling waterfowl or game), as net weights (for catching fish), or as charmstones (for some religious or magical use). A more recent analysis has proposed that they served as weights for looms (for weaving textiles).[9] It is certainly possible that these tools served multiple functions.

The suspension holes are fascinating. Some holes, especially in the hematite plummets, were drilled from two directions using a solid drill bit, presumably

Groundstone celts.

Ceramic tubular pipe. Artifact on loan from J. G. Powers and Bob Powers.

made of stone. Other holes, particularly in the magnetite plummets, were drilled from a single direction using a hollow drill bit, like cane. Why did they use a different drilling scheme to produce holes in the two different materials? We don't know for sure. They are similar in terms of their hardness, but the hematite generally contains more mineral inclusions, which might make drilling more difficult. Almost certainly they used a drilling machine, such as a *pump drill*, to create the holes in plummets, gorgets (decorative ornaments), and beads.

Smooth, relatively flat, perforated stone objects have puzzled archaeologists for many years. Found in different shapes and sizes, they may have served different purposes. Some are thought to have been used as weights for atlatls. Others may have been decorative ornaments called gorgets, or in other words, wearable art. Although they are mostly plain in appearance, sometimes the gorgets were adorned with incised lines, dots, or scalloped edges.

Some stone tools were made by pecking and grinding the stone into shape. Tools such as celts, adzes, and axes were probably mostly used for woodworking, although some may have been used as hoes for grubbing tubers or loosening soil for earthmoving. Other ground-stone tools, like *nutting stones*, mortars and pestles, and *manos and metates*, were made to pound or grind seeds and nuts. We

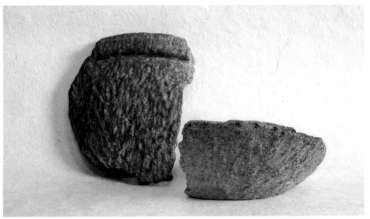

don't find many large metates at Poverty Point or other sites that were heavily farmed during the Historic Era. We think that farmers probably removed them so they didn't damage their plows.

Tubular stone and ceramic pipes were also part of the Poverty Point tool kit. They may have been smoking pipes for plants with hallucinogenic, stimulant, or healing properties. Some pipes may have been "sucking tubes," like those used by shamans in traditional healing ceremonies. We hope, one day, to examine the pipe interiors for preserved residues, which could be analyzed to determine what, if anything, was being smoked.

Although archaeologists first thought that Poverty Point was older than the appearance of pottery, that is not true. Pieces of pottery, called sherds, from both bowls and jars have been recovered from within and beneath the ridges. Some of the sherds look similar to types made in coastal Florida and the Tennessee Valley, suggesting that vessels were likely imported from those areas, but some were probably made right here. Pottery is not abundant; steatite (soapstone) and sandstone vessels appear to have been more common. Like the pottery, the stone vessels are now mostly fragments.

Pottery sherds.

Steatite bowl fragments.

Poverty Point owl pendant.

17 DECORATIVE OBJECTS

Jenny

During Poverty Point times there would have been much work to do—earthworks to design and build, food to hunt and gather, and homes to construct. It must have been time-consuming to survive with projectile points and atlatls and nuts gathered from the ground, even in such a rich ecosystem.

As I sit here on a cold Louisiana day, with overnight lows in the teens, I know winters would have been harsh for the Poverty Point dwellers also, even in the Deep South. Warm clothing would have had to be sewn, wood gathered for fires, and food sources may have been more scarce.

So I stare in awe at the vast array of decorative objects made at Poverty Point, items that served no utilitarian function, at least none that we know of. With all the work necessary to build, maintain, and grow Poverty Point, the people still found value in creating art, experienced the inspiration to do so, and put their hands to their mediums and brought it to life. As I photograph their ancient relics, I feel their enjoyment of the beautiful and the impractical, and the notion that time and energy are expended not only to build and sustain life but also to build a life worth living.

The owl pendants are so tiny and so intricately made. It is hard enough just to hold them securely—how could they have been created from the crude tools of Poverty Point times?

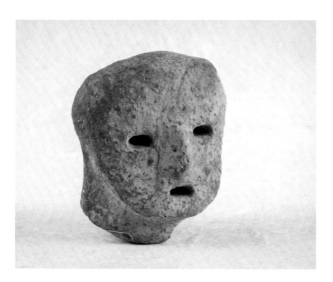

Figurine head.

Figurine torso.

Several figurines have been found at Poverty Point, mostly heads or torsos but few still intact. They are the only portraits we have of the people of this city. The face above seems to be speaking, as if caught in mid-sentence, the eyes empty but still somehow seeing.

Many of the torsos are of women and I have to wonder—who created them? Were they self-portraits or the likenesses of loved ones?

There is a large jump from the simple fired cubes of the Middle Archaic period to the work found at Poverty Point. There must have been a supportive framework for artists that allowed them the time to learn their crafts and create their work. And something must have sparked their creativity. Since much of their art depicts the human form or the natural world, I can only believe these were both of critical importance to them—their environment and each other.

Like mound building, the manufacturing of decorative objects blossomed at Poverty Point. There was a diversity of artistic expressions in clay and stone that exceeded the cultures that preceded it and followed it for nearly 1,200 years.

Most of the beads are made of highly polished chert stone, although other materials were used occasionally. There was apparently no "standard" as they are found in a great variety of shapes and sizes. Because drilling the hole seems like the riskiest part, one might think that would be one of the first steps in making a bead. We know from unfinished specimens, though, that a lot of work went into shaping the stone first and that drilling the hole was one of the last steps, just before the final shaping and polishing.

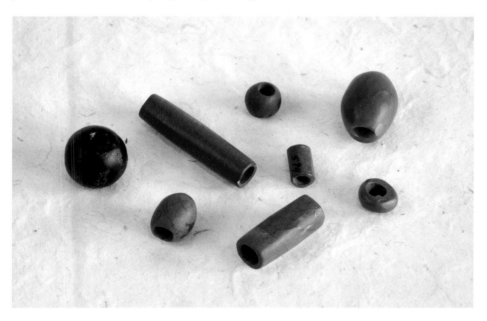

Chert beads.

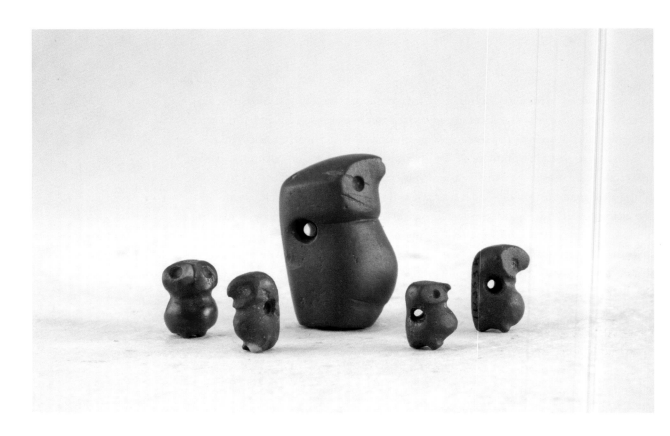

Pot-bellied owl pendants of red jasper.

The "pot-bellied" owl pendants are considered to be a classic artifact of the Poverty Point culture, with most of the nearly thirty owls known to date found at sites other than Poverty Point.[10] Poverty Point does have the greatest number of owls from any one site, but they have been found over a wide area, from eastern Florida to western Louisiana. These tiny pendants are usually made of red jasper, but other materials such as fluorite and galena have been used as well. The jasper owls show a surprising amount of detail and excellent craftsmanship, with miniature feet, curved beaks, and drilled eye cones. The largest owl from

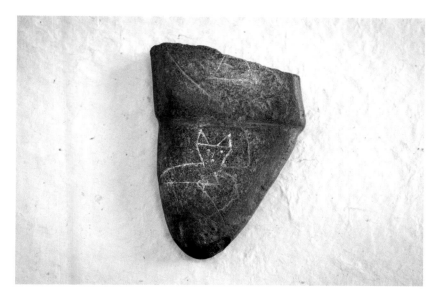

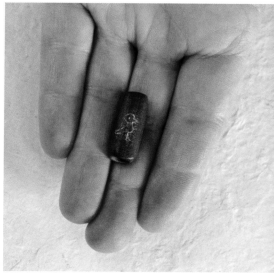

"Fox Man" etching.

Chert bead with bird etching.

Poverty Point stands 1.1 inches tall. No owl pendants have been recovered during excavations here—they were picked up from the surface. Four finished owls are on display in the Poverty Point museum, along with some "preforms," which are artifacts that have been "roughed out" but not completed.

Etching was a common decorative technique, as seen on this tablet or gorget fragment showing a "Fox Man" figure.[11]

And this bead with a bird etched into it.

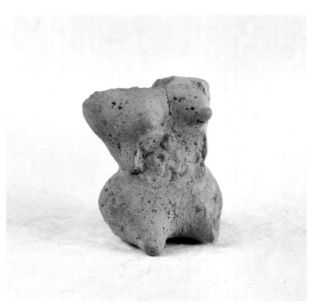 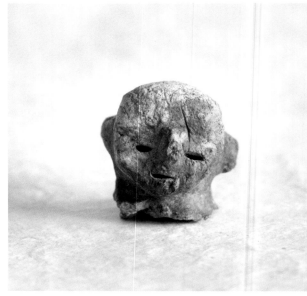

Figurine torso.

Figurine head.

It is true that most of the ceramic figurines represent women and most are broken. There are only a few whole ones. We generally find torsos or heads, and we don't find the heads near the bodies, as we would if they were broken in place. Archaeologists have speculated that they could have been deliberately broken as part of death or childbirth rituals. Really, though, we don't know why they are like this.

Decorative fired-earth objects are found in a variety of shapes, sizes, and designs. Some resemble highly decorated PPOs, although they are not found in earth ovens as PPOs often are found. This suggests that they served another purpose. Most are abstract designs, but a few naturalistic items, like the lotus pod, have been recovered.

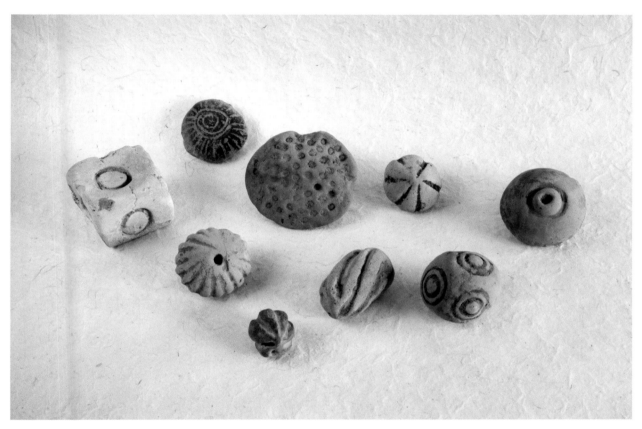

Decorative fired-earth objects. Lotus pod replica is in the back row, center.

IV POST–POVERTY POINT

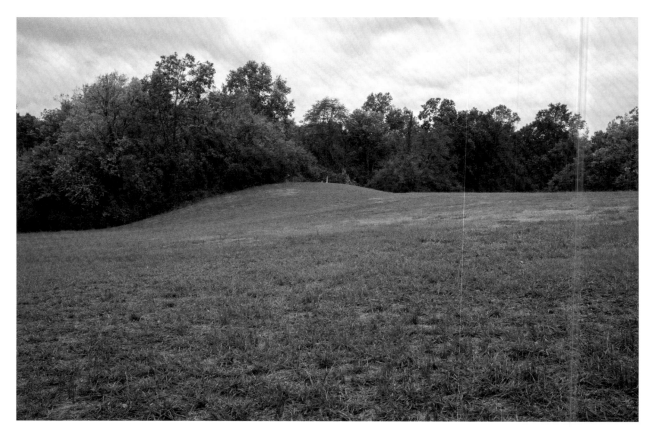

Mound D.

18 MOUND D

Jenny

After Poverty Point was deserted by the culture that built it, it was lightly used by others who were just passing through. Around AD 700, nearly two thousand years after Poverty Point was abandoned, a new earthwork was added to the complex.

Mound D is from the Late Woodland period. It lies in the southeastern section of Poverty Point, near the dock and near where the southern ridges reach Bayou Maçon.

Was it the elevation that enticed people to build here atop an old Poverty Point ridge? The proximity to the dock? Or was it a connection to their past that brought them back?

From its summit, in the cold and quiet of a December day, I hear dry leaves rustling in the nearby woods and the deeper, louder thuds of deer. I catch the flash of a white tail disappearing in the brush—or maybe it is just the wagging of a pale leaf on the skeletal branch of an oak tree.

Mound D.

109

Diana

Sometime around 1100 BC, something happened and life at Poverty Point ended. We aren't certain why, but people apparently moved away. There is evidence of a climatic change around that time. Perhaps the resource base was disturbed enough by excessive flooding that it couldn't support a relatively large population living year-round in one place.[1] The people left, whether all at once or in dribs and drabs we don't know. They stopped building earthworks. They stopped, or nearly so, acquiring exotic materials and making decorative items. In short, the things we call cultural elaborations were no longer an important part of their lives, and this presumably freed up time and energy that could be spent on survival. For 400 years after Poverty Point, there is no evidence of mound building in the Lower Mississippi Valley. Then it started back up again, but the first mounds were small; after that, they vary in size and shape, but ones that can match or exceed the monumentality of Poverty Point weren't built until much later.

We find artifacts diagnostic of later cultures at Poverty Point: dart points, arrow points, a series of ceramic wares. Accumulated for 2,500 years or so, they number

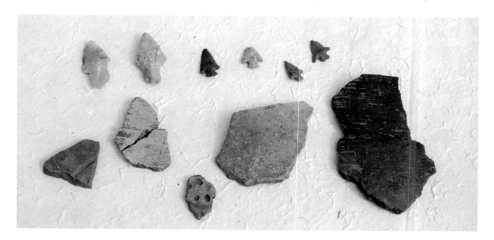

Dart and arrow points and pottery sherds that post-date the Poverty Point occupation. Arranged generally from oldest to youngest, left to right.

only a fraction of those we can attribute to the Poverty Point occupation. Archaeologists haven't focused much time on studying these latecomers, but there is no evidence for a major settlement, just ephemeral camps or maybe short-term hamlets.

Mound D is the most significant evidence of a later Native American use of the site. Located on the eastern edge of Macon Ridge, it is a small mound, about 100 by 130 feet at its base, extending about 6 feet above the adjacent plaza. There are ceramics around and in the mound that are diagnostic of the Coles Creek culture (AD 700–1200).* For many years there was confusion about Mound D. Was it just an undamaged section of a ridge, spared from plowing? Was it a Poverty Point mound? Was it a Coles Creek mound on a Poverty Point ridge? Or, was it a Historic Era mound built by Euroamerican settlers, containing artifacts that were lying on the surface when nearby earth was pushed to form a pile?

In 2011, Thurman Allen, Joe Saunders, and I extracted some soil cores from Mound D. The cores showed a natural soil at the bottom, overlain by a construction with a well-developed soil (comparable to the Poverty Point earthworks), which was covered by a less developed soil (too well developed to be a modern addition, but too weakly developed to be Poverty Point aged). Anthony Ortmann obtained radiocarbon dates from the lower construction that were clearly Poverty Point in age.[2] Luminescence dates indicated that the uppermost earth layers were a Late Woodland addition. Thus, Mound D is a Coles Creek mound on a Poverty Point ridge.

Why would later peoples build a mound at Poverty Point if they did not live there? There is a site, south of Poverty Point, that was occupied by people of the Coles Creek culture. Known as the Jackson Place site (see LiDAR image on page 17), it had, at one time, several earthworks. Perhaps Mound D could be the northernmost earthwork of that complex.

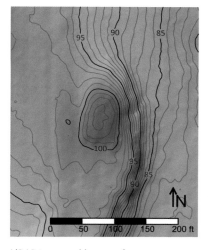

LiDAR topographic map of Mound D. LiDAR data courtesy of FEMA and the state of Louisiana, and distributed by "Atlas: The Louisiana Statewide GIS," LSU CADGIS Research Laboratory, Baton Rouge, Louisiana.

*The Coles Creek culture of the Lower Mississippi Valley is distinct from Poverty Point culture in several ways in addition to age. In both cultures the people built mound complexes, with multiple mounds (these were platform mounds) around a central plaza, but for the Coles Creek these were primarily ceremonial sites and most people lived in settlements located around the mound centers. The people still hunted, fished, and gathered, but they also gardened local plants such as goosefoot and maygrass. Artifact assemblages contain abundant pottery sherds and arrow points (the bow and arrow had been introduced by this time), with stone tools made from local sources of stone rather than exotic ones.

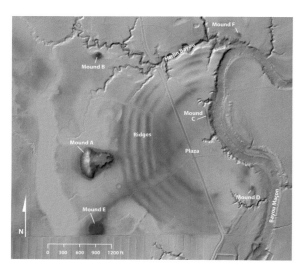

LiDAR topographic map of the earthworks of Poverty Point. LiDAR data courtesy of FEMA and the state of Louisiana, and distributed by "Atlas: The Louisiana Statewide GIS," LSU CADGIS Research Laboratory, Baton Rouge, Louisiana.

After the Coles Creek addition to the Poverty Point earthworks, arrow points and pottery indicate light use of the site until about AD 1450. From then until Euroamericans settled the area in the early 1800s, there is no evidence of human activity here.

Now we've covered all of the earthen components of Poverty Point, showing how the site developed from a single mound, Mound B, to the final elaborate design. It might be simpler if the mound names, those letters A–F, reflected their age from oldest to youngest, but that isn't how it works. The logic is actually quite straightforward, though. Beginning with the big mound, Mound A, and proceeding clockwise, we have Mounds B, C, D, and E. Mound F, the last mound identified on the site, breaks the pattern and just assumes the next letter in the alphabet.

People often wonder which Native American tribe was responsible for building the Poverty Point earthworks and Mound D. After all, it would be easier to talk about them and to give them a face if we had a name. Without records, we can't know what they called themselves. And so much time has elapsed since the construction and occupation of Poverty Point, and there has been so much cultural change and movement across the landscape, especially after Europeans arrived on the continent, that we really cannot specify any particular Native American tribe as the creators of this magnificent place.

19 THE HISTORIC ERA

Jenny

On my first trip to the newly discovered Mound F, I walked alongside archaeology students as they poked through the vines, leaf litter, and poison ivy that covered the earthwork. They discovered glassware and other historic artifacts, inspected them, and then returned them to the ground. It was obvious we were not the first modern-day visitors.

In the early 1800s, a young man from Kentucky, Jacob Walter, came south to Louisiana in search of lead ore. His journal, handwritten on unlined paper, is

Glass bottle found at Mound F.

Glass fragment found at Mound F.

the first written account of Poverty Point. Walter wrote of meeting "with the vestiges of antique footsteps" and exploring the site of an old "indian town" on Bayou Maçon. He discovered a profusion of clay balls strewn across the ground for several acres that "were the size of a green walnut and had been baked in fire." Riding his horse to the top of a mound that he described as being a "colossal size," he described an "inclined plane attached to one side, with a grade, so as to enable one to ride up on it with ease." He wrote: "It has been the habit of mankind, from the earliest history of existence—both oral and written—that mankind has ever sought elevated places to worship god or a great spirit as they may term it."

Steamboats paddled their way up Bayou Maçon during the 1800s, and the old wagon road that cut through Mound C was formed. In the late 1840s the property was bought by Philip Guier, and he named his new farm Poverty Point Plantation. The timber was cut and the fields were planted, mostly in cotton.

The Guier family added a cemetery to the top of Mound D, which is also known as Sarah's Mound, named for Sarah Guier, Philip's wife, who is buried there. I have stood on its slight summit in twenty-first-century sneakers, amid a nineteenth-century cemetery built on an AD 700 mound that is built on top of a 1300 BC Poverty Point–era ridge. There is no denying our connection to the past.

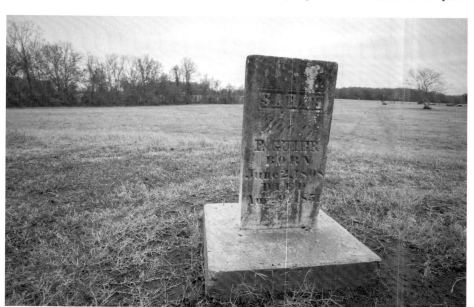

Gravestone atop Mound D.

Diana

Details about the earliest Euroamerican presence at Poverty Point are scarce, but we can piece together a general outline.[3] Acreage that includes Poverty Point was probably first settled by John Dempsey in the 1810s or '20s. In 1837, the land, which included a cotton gin, and seven slaves were purchased by Philip Guier. The Government Land Office survey map of 1848 shows Guier's holdings, along with a building (probably a house) and an "Indian Mound." This is Mound B, the first mound mapped, only because it sat on a section line.

Sometime prior to the mid-1850s, Guier apparently named his land Poverty Point Plantation. The archaeological site clearly takes its name from that nineteenth-century plantation, but how did the plantation get its name? We don't know for sure, but a couple of different possibilities have been suggested:

It is known that Guier, like many planters of that time, also owned prime agricultural land on the Mississippi River floodplain. The floodplain soils of his Hollybrook Plantation were much better suited to growing cotton than the soils on Macon Ridge, and Hollybrook likely outproduced Poverty Point by a large margin. Secondary, upland holdings were often given names to reflect that inferior status, names like "Hard Bargain," "Hard Times," and "Poverty Point."

Alternatively, it is suspected that Guier traveled back and forth on the Mississippi River to visit kin living farther north. He might have noticed a sharp bend in the river south of Princeton, Mississippi, in northern Issaquena County at a place called Poverty Point. If he recognized that river bend as being similar to the bend in Bayou Maçon, perhaps that was the source of the name Poverty Point Plantation.

Guier eventually sold Poverty Point Plantation. A confiscated Confederate map from the Civil War suggests it was abandoned during the conflict. When farming resumed, it was apparently with some sort of sharecropping or tenant-farming system. Several tenant families lived on the property, as evidenced by the artifacts they left behind.

There are two headstones on Mound D, one for Sarah Guier and the other for Amanda Malvina, whom we don't know, but perhaps she was a relative. Geophysical survey conducted several years ago suggests two more individuals may be buried there as well. There is also an unmarked cemetery in an elevated portion of Ridge 1 that has been identified as a "burial ground for deceased slaves in the early nineteenth century."[4] And two Historic Era infants were found buried about two feet below the surface of Mound B.[5] So, there is a record of death in the two hundred years that Euroamericans have occupied the site. In contrast, for the Poverty Point people, we find no burials, no grave-shaped holes that could have contained bodies since leached away, no deposits of cremated remains. It could be that we haven't look in the right places. Or, more likely, the people of Poverty Point did something else with their dead. Maybe they laid them out for the elements to reclaim or sent them downstream in a boat or took them to an off-site cemetery. It's another Poverty Point mystery.

The state of Louisiana purchased the property in 1972, and the Office of State Parks manages it as a state historic site. It is currently open to the public, 9 a.m. to 5 p.m., 362 days per year (closed Thanksgiving Day, Christmas Day, and New Year's Day). There is a visitors' center with a museum and theater. From March through October, ranger-guided tram tours are offered four times daily; outside of those months, visitors may use their personal vehicles to take a self-guided driving tour. There is also a 2.6-mile self-guided hiking trail through the earthworks.

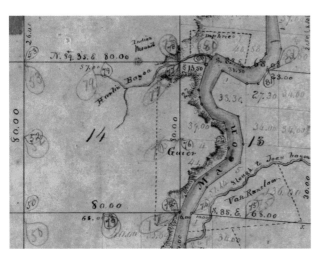

Portion of Government Land Office survey map, showing the Poverty Point locale, 1848. Map (No. 523.01041_1) courtesy of the Louisiana Office of State Lands, wwwslodms.doa.la.gov/HistoricalDocument.

Today, Poverty Point State Historic Site serves as an anchor point for the Indian Mounds of Northeast Louisiana driving trail. Each of the 39 mound sites on the trail has a historic marker containing information about the site; maps and additional information are included in the associated driving guide. The mounds of the driving trail, which reflect the range of mound-building cultures that inhabited northeast Louisiana, are a sample of the more than 700 mound sites recorded in Louisiana. Information about the driving trail is available at Poverty Point State Historic Site.

Poverty Point is not only a Louisiana State Historic Site, but also a National Historic Landmark and a National Monument. These designations, awarded in 1962 and 1988, respectively, acknowledge the importance of Poverty Point to the heritage of the United States and aid in its protection.

In 2014, Poverty Point was recognized as an internationally significant site when the World Heritage Committee inscribed Poverty Point on the United Nations Educational, Scientific and Cultural Organization (UNESCO) World Heritage List. The World Heritage List contains only the most extraordinary natural and cultural properties that are considered to be important to all of humanity. The list includes cultural sites such as the Great Wall (China), Stonehenge (United Kingdom), the city of Pompeii (Italy), Machu Picchu (Peru), and the Great Pyramid (Egypt), as well as natural sites such as the Great Barrier Reef (Australia) and the Galápagos Islands (Ecuador).

Segment of map of the Mississippi River, showing the landform known as Poverty Point (Suter and Blaisdell, 1874). Map courtesy of the Mississippi River Commission; color added.

Only twenty-two places in the United States are World Heritage sites. Twelve are natural sites (e.g., Grand Canyon National Park, Everglades National Park), nine are cultural properties (e.g., Statue of Liberty, Independence Hall), and one is a mixed property, with outstanding cultural and natural characteristics (Papahānaumokuākea Marine National Monument). Three of the cultural properties are archaeological sites (Cahokia Mounds State Historic Site, Mesa Verde National Park, and Chaco Culture). Poverty Point is in fine company.

There are some misconceptions about the World Heritage program. Perhaps the most pervasive is that the United Nations will take over ownership and/or management of Poverty Point. That is not true. The state of Louisiana still owns and the Louisiana Office of State Parks (in collaboration with the Poverty Point Station Archaeology Program) still manages the site, and there is no reason to believe that this will change. Being on the World Heritage List is an honor, but only an honor.

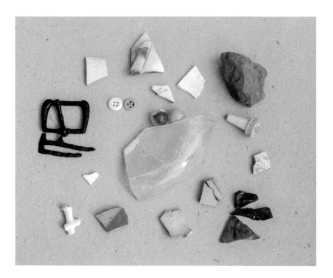

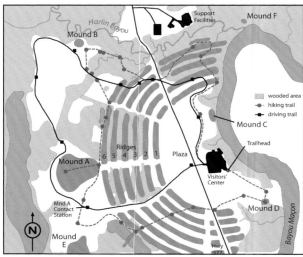

Historic Era artifacts from Poverty Point.

Schematic of Poverty Point State Historic Site.

What does inclusion on the World Heritage List mean for Poverty Point, beyond expert recognition of its international significance? Primarily, it will increase public awareness of this extraordinary site. Although most archaeologists know about Poverty Point, relatively few members of the general public outside of northeast Louisiana have ever heard of it. As awareness of the site increases, the number of people who want to experience it may multiply, and maybe they will develop a greater appreciation for the achievements of the Native Americans who lived here so long ago. I hope that they will want to learn about and protect other Native American archaeological sites as well. On the practical side, for those of us who care for Poverty Point, this designation will allow us to consult with other experts about how to best preserve this amazing site for future generations.

EPILOGUE

Jenny

It's mid-September 2013, and I am at Poverty Point for a full-moon night hike. There's a small group assembled, leftovers from a meeting earlier in the day—doctors, city councilmen, lawyers, and a few of us nontitled individuals. We coat ourselves in DEET-laced bug spray and head into the fading evening light. Armadillos are beginning their "day," and we cross paths frequently. They shuffle past us in their armored suits, dragging their tails through the dirt, and I think about snakes. I don't want to think about snakes, but I do anyway.

We pass Mound C and are soon engulfed by the trees that cover the north ridges. I stop frequently to set up my tripod to photograph and soon get left behind by the main group. I pick my way through the darkness, stepping carefully through the grass, following the sounds of muffled voices. I wish for the eyesight of the Poverty Point inhabitants and their innocence of artificial lighting. I wish for the ability to walk boldly in what would have been brightness to them, the full moon illuminating well-worn paths through their familiar surroundings.

The rangers build a fire though the night isn't really cold enough for one. I listen as the wood crackles and watch as sparks fly into the sky. Stories are told as I imagine stories were told here for centuries—some honestly, others in half-truths and embellishments.

As we make our way to the big mound, Mound A, I pause once again to photograph. Standing in the shadows near the slough, I hear a barred owl hooting. I listen to its call and wonder if it is just distance that separates us or if, maybe, just

Night at Poverty Point.

Campfire at Poverty Point.

maybe, it is time also—a Late Archaic owl come to visit. Some Native Americans believed owls were associated with death, and their calls were thought to be from the spirits of the dead. Others believed they were protectors of warriors. On this night I prefer to think of them as ancient spirits and another connection between me and the Poverty Point past.

The darkness absorbs the power lines and road traffic, and I am left with trees and shadows and my imagination. Quiet descends and the ancient past feels so much closer. I conjure up sleeping villagers and the soothing voices of mothers putting children to bed.

I think of the long gap after Poverty Point was abandoned, when this city languished for thousands of years, overgrown and invisible. I look up at the summit of Mound A and am grateful that visitors are now returning here, that there are people committed to protecting the site and who advocate for its care and preservation. And I wish, fervently, that all who come here will see this great city as it once was and take the time to honor the bold and creative people who built it.

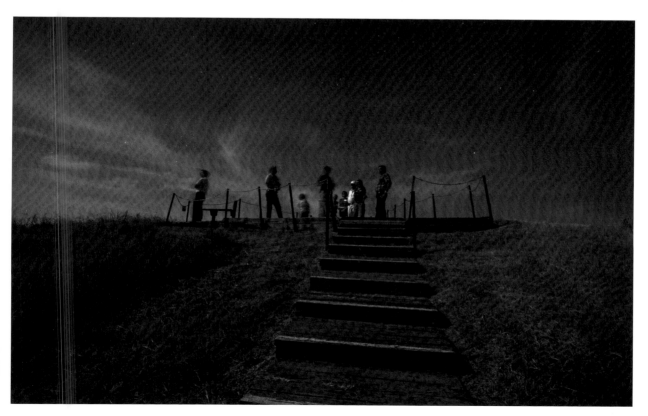

The summit of Mound A.

NOTES

INTRODUCTION

1. Moore 2003, 607.

2. Connolly 1999.

I. PRE–POVERTY POINT

1. Rees 2010.

2. Seeman et al. 2008.

3. Miller 2013; Waters et al. 2011.

4. Saunders, Allen, and Saucier 1994; Saunders et al. 1997.

5. Saunders 2010.

6. Saunders et al. 2001.

7. Dunnell 1989, 1999; Hamilton 1999; Peacock and Rafferty 2013.

8. Neiman 1997.

9. Dunnell 1989; Madsen, Lipo, and Cannon 1999.

10. Saunders 2010; Greenlee and Saunders 2008.

11. Adelsberger and Kidder 2007; Sampson 2008; Peacock and Rafferty 2013.

II. THE CITY OF POVERTY POINT

1. Saunders et al. 2001; Saunders et al. 2005.

2. Adelsberger and Kidder 2007.

3. Ford 1955; Ford and Webb 1956.

4. Reimer et al. 2013.

5. Ortmann 2010.

6. Ford 1955.

7. Gibson 1990.

8. Kidder, Ortmann, and Allen 2004; Ortmann 2010.

9. Saunders and Allen 1994; Saunders, Allen, and Saucier 1994; Saunders et al. 2001.

10. Scharf 2013.

11. Transcribed by Greenlee from "Bringing the Past Alive," a seminar recorded in April 1989, at Louisiana State University and provided by Ann F. Ramenofsky.

12. Ford 1954; Ford and Webb 1956.

13. Gibson 1990; Webb 1982.

14. Connolly 2002.

15. Woodiel 1990, 62.

16. Hargrave et al. 2010.

17. Dalan et al. 2010.

18. Fowke 1928, 435.

19. Ortmann and Kidder 2013; Kidder, Ortmann, and Arco 2008.

20. Ortmann 2010.

21. Gibson 1984.

22. Comer and Wimbrow 2012, 10.

III. LIFE AT POVERTY POINT

1. Gibson 1990; Lenzer 1978.
2. Scharf 2013.
3. Cummings 2003.
4. Greenlee and Seltzer 2009.
5. Lenzer 1978.
6. Gibson 1994.
7. Pierce 1998.
8. Nassaney and Pyle 1999.
9. Lipo, Hunt, and Dunnell 2012.
10. Saunders 2007.
11. Gibson 1999.

IV. POST–POVERTY POINT

1. Kidder 2006, 2010; but see Gibson 2010.
2. Ortmann 2010.
3. Reonas 2012.
4. Haag, 1990, 4.
5. Ford and Webb 1956.

GLOSSARY

artifact

An object that owes its form or location to human activity. Although many people associate the term *artifact* with ancient objects, there is no age criterion—it applies equally well to objects of modern life.

atlatl

A spear-thrower. A shaft of wood, held in the hand at one end, with a hook or notch in the other end against which a spear was butted. The shaft serves as a lever that essentially lengthens the arm, thus allowing a dart or spear to be propelled with greater force than possible by simply throwing it. Atlatl weights, an antler atlatl hook, and spear points are the only parts of the spear-throwing tool system preserved at Poverty Point.

bet-hedging

A pattern seen among plants and animals living in an unpredictably variable environment, wherein fewer offspring than maximally possible are produced, thereby increasing the likelihood of the survival of those offspring.

calibration

A program to convert radiocarbon years into calendar years. As an example, the age of the Clovis culture is about 11,200–10,900 radiocarbon years ago, but that far back, radiocarbon years diverge quite a bit from calendar years. So, 11,000 radiocarbon years ago is about 13,000 calendar years ago (or 11,000 BC).

carrying capacity

The maximum number of individuals of a species that a particular environment can sustainably support. In the case of people, the carrying capacity will also be determined by their technology—for example, how they acquire food (as hunter-gatherers or as agriculturalists) or if they store it.

celt

An adze- or axe-like stone tool, with a wedge-shaped cutting end and lacking a groove or other obvious hafting feature.

context

The vertical and horizontal location of an artifact, the sediments it was found in, and the other artifacts it was found with. Context is critically important to understanding past cultures because it provides information about how old an artifact is, how it relates to other artifacts, and how it ended up where it was found.

cultural elaborations

Monumental architecture or nonutilitarian objects that divert energy and resources from survival and reproduction.

daub

Earth packed onto a framework of sticks, called wattle, that was used to form house walls. If a house burns, the daub is fired and impressions of sticks, cane, Spanish moss, and human palm prints can be preserved.

diagnostic artifacts

Artifacts with characteristics that are representative of a particular time period.

feature

A nonportable artifact—an object made by people, but that is too large or too fragile to be moved without destroying it. Fire hearths, earth ovens, postholes, pits, graves, house floors, and mounds are all examples of features.

geophysical survey

The mapping of features and other phenomena below the ground surface without excavation. Special instruments are used to measure and record variations in soil properties such as magnetic field strength

and magnetic susceptibility, electrical resistance, and electrical conductance.

LiDAR
A remote sensing technology similar to radar, but that uses light instead of radio waves. In archaeology LiDAR is used for making detailed topographic maps.

luminescence dating
A dating method that determines the length of time since certain kinds of material, including pottery sherds, stone tools, and soil, were last heated or exposed to sunlight by measuring the number of electrons trapped in quartz or feldspar grains. These electrons have been accumulating since the material was last heated or exposed to sunlight; the more trapped electrons, the longer the elapsed time.

mano and metate
A metate is a large grinding stone with a smooth trough or concaved surface. A mano is the hand-held grinding implement used to crush and grind seeds or nut meats against the metate.

megafauna
Extinct, oversized animals (much larger than their modern counterparts) that lived, in this case, during the last Ice Age. Such creatures include mammoths, mastodons, and giant ground sloths.

midden
Dark soil containing the debris from everyday living. The accumulation of broken and discarded tools, food scraps, and other sorts of domestic waste from habitation results in dark soils full of artifacts.

nutting stone
A rock, usually sandstone, with one or more small depressions about the shape of a large nut. The stone formed the base upon which a hard-shelled nut was placed and whacked with another rock, a hammerstone, to crack it. Over time, a depression was worn into the stone.

pecking and grinding
A technique for manufacturing groundstone tools. The tool's rough shape is obtained by pecking, wherein a hammerstone is used to strike the tool and remove small chunks of stone. Its final shape and surface finish are obtained by grinding.

pedogenesis
The development of different layers, or horizons, in soil. The rate at which horizons form is a function of time, climate, the kinds of plants and animals that are around, the texture of the dirt, and topography (Jenny 1941). When these factors other than time are more or less the same, then the degree of soil development will reflect the relative ages of the soils.

phytoliths
Glasslike microscopic structures that form in plant cells. Some plants produce phytoliths with distinctive shapes, allowing scientists to establish the presence of those plants long after they have died and decayed.

posthole
A cylindrical cut in the soil representing the pit into which a post was set. It may contain soil washed or slumped in from the surrounding soil, a different soil if the hole was purposely filled, or a postmold.

postmold
A cylindrical stain in the soil that remains from a decayed wood post.

pump drill
A simple drilling machine. It has a main shaft, to which weights and a stone or cane drill bit are attached, a crosspiece that can slide up and down the shaft, and a line or cord that is attached to each end of the crosspiece and runs through a hole in the top of the shaft. The crosspiece slides up and down the shaft, twisting and untwisting the cord, and causing the shaft and the attached drill bit to rotate.

radiocarbon dating
A method for dating the death of an organism by measuring the amount of radioactive carbon (carbon-14) left in the wood, bone, or tooth (or whatever has survived). By knowing how much radiocarbon it started with and the decay rate, scientists can determine when the organism died.

soil core
A plug of soil, usually 1 or 2 inches in diameter, extracted from the ground by a manual probe or hydraulic coring rig. Archaeologists look for changes in the color or texture of the soil with depth, and for artifacts (like fragments of fired earth) or charred wood.

use wear
Chips, scratches, and polishes resulting from using a tool. Archaeologists use a microscope to examine the distribution, orientation, and severity of damage to determine how a tool was used, and sometimes what kind of material it was used on.

REFERENCES

Adelsberger, Katherine A., and Tristram R. Kidder. 2007. "Climate Change, Landscape Evolution, and Human Settlement in the Lower Mississippi Valley, 5500–2400 Cal B.P." In *Reconstructing Human-Landscape Interactions*, edited by Lucy Wilson, Pam Dickinson and Jason Jeandron, 84–108. Newcastle, UK: Cambridge Scholars Publishing.

Comer, Douglas C., and Miles Wimbrow. 2012. "Poverty Point Space Syntax Analysis." Unpublished report on file with the Poverty Point Station Archaeology Program, Epps, LA. Baltimore: CSRM Foundation.

Connolly, Robert P. 1999. "1999 Annual Report: Station Archaeology Program at the Poverty Point State Commemorative Area." Unpublished report on file with the Poverty Point Station Archaeology Program, Epps, LA. Monroe: Department of Geosciences, Northeast Louisiana University.

———. 2002. "The 1980–1982 Excavations on the Northwest Ridge 1 at the Poverty Point Site." *Louisiana Archaeology* 25:1–92.

Cummings, Linda Scott. 2003. "Microscopic Examination of Pollen, Phytolith, and Starch Removed from Poverty Point Objects, Poverty Point, Louisiana." Technical Report 01-89. Golden, CO: PaleoResearch Institute.

Dalan, Rinita A., Jessica Beard, Alissa Blaha, and Avery Cota. 2010. "Magnetic Susceptibility Studies at the Poverty Point State Historic Site." Unpublished report on file with the Poverty Point Station Archaeology Program, Epps, LA. Moorhead: Minnesota State University Moorhead.

Dunnell, Robert C. 1989. "Aspects of the Application of Evolutionary Theory in Archaeology." In *Archaeological Thought in America*, edited by C. C. Lamberg-Karlovsky, 35–49. Cambridge: Cambridge University Press.

———. 1999. "The Concept of Waste in an Evolutionary Archaeology." *Journal of Anthropological Archaeology* 18:243–50.

Ford, James A. 1954. "Additional Notes on the Poverty Point Site in Northern Louisiana." *American Antiquity* 19:282–85.

———. 1955. "The Puzzle of Poverty Point." *Natural History*, 466–72.

Ford, James A., and Clarence H. Webb. 1956. "Poverty Point, a Late Archaic Site in Louisiana." Anthropological Papers, vol. 46, part 1. New York: American Museum of Natural History.

Fowke, Gerard. 1928. "Mounds in West Carroll and Richland Parishes, LA." *Forty-Fourth Annual Report of the Bureau of American Ethnology, 1926–1927*. Washington, DC: U.S. Government Printing Office, 434–36.

Gibson, Jon L. 1984. "The Earthen Face of Civilization: Mapping and Testing at Poverty Point, 1983." Unpublished report on file with the Poverty Point Station Archaeology Program, Epps, LA. Lafayette: University of Southwestern Louisiana.

———. 1990. "Earth Sitting: Architectural Masses at Poverty Point, Northeastern Louisiana." *Louisiana Archaeology* 13:201–48.

———. 1994. "Empirical Characterization of Exchange Systems in Lower Mississippi Valley Prehistory." In *Prehistoric Exchange Systems in North America*, edited by Timothy G. Baugh and Jonathon E. Ericson, 127–75. New York: Plenum Press.

———. 1999. *Poverty Point: A Terminal Archaic Culture of the Lower Mississippi Valley*, 2nd ed. Anthropological Study Series, no. 7. Baton Rouge: Louisiana Archaeological Survey and Antiquities Commission.

———. 2010. "'Nothing but the River's Flood': Late Archaic Diaspora or Disengagement in the Lower Mississippi Valley and Southeastern North America." In *Trend, Tradition, and Turmoil: What Happened to the Southeastern Archaic?* edited by David Hurst Thomas and Matthew C. Sanger, 33–42. New York: American Museum of Natural History.

Greenlee, Diana, and Joe Saunders. 2008. "Is Earthwork Construction in the Lower Mississippi Valley Discontinuous, or Does It Only Appear That Way?" Poster presented at the 65th Annual Meeting of the Southeastern Archaeological Conference, Charlotte, NC.

Greenlee, Diana, and Jennifer Seltzer. 2009. "Reconstructing the Vegetative Landscape at Poverty Point." Paper presented at the Joint Annual Meeting of the Mississippi Archaeological Association and the Louisiana Archaeological Society, Natchez, MS.

Haag, William G. 1990. "Excavations at the Poverty Point Site, 1972–1975." *Louisiana Archaeology* 13:1–39.

Hamilton, Fran E. 1999. "Southeastern Archaic Mounds: Examples of Elaboration in a Temporally Fluctuating Environment?" *Journal of Anthropological Archaeology* 18:344–55.

Hargrave, Michael, R. Berle Clay, Rinita Dalan, and Lewis Somers. 2010. "Recent Magnetic Gradient, Susceptibility, and Resistance Surveys at Poverty Point." Paper presented at the 75th Annual Meeting of the Society for American Archaeology, St. Louis, MO.

Jenny, Hans. 1941. *Factors of Soil Formation: A System of Quantitative Pedology.* New York: McGraw-Hill.

Kidder, Tristram R. 2006. "Climate Change and the Archaic to Woodland Transition (3000–2500 Cal B.P.) in the Mississippi River Basin." *American Antiquity* 71:195–231.

———. 2010. "Trend, Tradition, and Transition at the End of the Archaic." In *Trend, Tradition, and Turmoil: What Happened to the Southeastern Archaic?* edited by David Hurst Thomas and

Matthew C. Sanger, 23–32. New York: American Museum of Natural History.

Kidder, Tristram R., Anthony Ortmann, and Thurman Allen. 2004. "Testing Mounds B and E at Poverty Point." *Southeastern Archaeology* 23:98–113.

Kidder, Tristram R., Anthony L. Ortmann, and Lee J. Arco. 2008. "Poverty Point and the Archaeology of Singularity." *SAA Archaeological Record* 8:9–12.

Lenzer, John P. 1978. "Geomorphology." In *The Peripheries of Poverty Point*, edited by Prentice M. Thomas, Jr., and L. Janice Campbell, 24–57. Report of Investigations no. 12. Fort Walton Beach, FL: New World Research, Inc.

Lipo, Carl P., Timothy D. Hunt, and Robert C. Dunnell. 2012. "Formal Analyses and Functional Accounts of Groundstone 'Plummets' from Poverty Point, Louisiana." *Journal of Archaeological Science* 39:84–91.

Madsen, Mark, Carl Lipo, and Michael Cannon. 1999. "Fitness and Reproductive Trade-Offs in Uncertain Environments: Explaining the Evolution of Cultural Elaboration." *Journal of Anthropological Archaeology* 18:251–81.

McKoin, Florence Stewart. 1971. *Between the Rivers: A West Carroll Chronicle.* Baton Rouge: Claitor's Publishing Division.

Miller, G. Logan. 2013. "Illuminating Activities at Paleo Crossing (33ME274) through Microwear Analysis." *Lithic Technology* 38:97–108.

Moore, Clarence Bloomfield. 2003. "Some Aboriginal Sites in Louisiana and in Arkansas: Atchafalaya River, Lake Larto, Tensas River, Bayou Maçon, Bayou D'Arbonne, in Louisiana; Saline River, in Arkansas." In *The Louisiana and Arkansas Expeditions of Clarence Bloomfield Moore*, edited by Richard A. Weinstein, David B. Kelley, and Joe W. Saunders, 567–659. Facsimile of the 1913 publication. Tuscaloosa: University of Alabama Press.

Nassaney, Michael S., and Kendra Pyle. 1999. "The Adoption of the Bow and Arrow in Eastern North America: A View from Central Arkansas." *American Antiquity* 64:243–63.

Neiman, Fraser D. 1997. "Conspicuous Consumption as Wasteful Advertising: A Darwinian Perspective on Spatial Patterns in

Classic Maya Terminal Monument Dates." In *Rediscovering Darwin: Evolutionary Theory in Archaeological Explanation*, edited by C. M. Barton and G. A. Clark, 267–90. Archaeological Papers no. 7. Arlington, VA: American Anthropological Association.

Ortmann, Anthony L. 2010. "Placing the Poverty Point Mounds in Their Temporal Context." *American Antiquity* 75:657–78.

Ortmann, Anthony L., and Tristram R. Kidder. 2013. "Building Mound A at Poverty Point, Louisiana: Monumental Public Architecture, Ritual Practice, and Implications for Hunter-Gatherer Complexity." *Geoarchaeology: An International Journal* 28:66–86.

Peacock, Evan, and Janet Rafferty. 2013. "The Bet-Hedging Model as an Explanatory Framework for the Evolution of Mound Building in the Southeastern United States." In *Beyond Barrows: Current Research on the Structuration and Perception of the Prehistoric Landscape through Monuments*, edited by D. Fontijn, A. J. Louwen, S. van der Vaart, and K. Wentink, 253–79. Leiden, Neth.: Sidestone Press.

Pierce, Christopher. 1998. "Theory, Measurement, and Explanation: Variable Shapes in Poverty Point Objects." In *Unit Issues in Archaeology: Measuring Time, Space, and Material*, edited by Ann F. Ramenofsky and Anastasia Steffen, 163–89. Salt Lake City: University of Utah Press.

Rees, Mark. 2010. "Paleoindian and Early Archaic." In *Archaeology of Louisiana*, edited by Mark Rees, 34–62. Baton Rouge: Louisiana State University Press.

Reimer, Paula J., Edouard Bard, Alex Bayliss, J. Warren Beck, Paul G. Blackwell, Christopher Bronk Ramsey, Caitlin E. Buck, et al. 2013. "IntCal13 and Marine13 Radiocarbon Age Calibration Curves 0–50,000 Years Cal BP." *Radiocarbon* 55:1869–87.

Reonas, Matthew. 2012. "Poverty Point in the Historic Period, 1800–1970." Unpublished report on file with the Poverty Point Station Archaeology Program, Epps, LA.

Sampson, C. Garth. 2008. "Middle Archaic Earth Mounds in the American Southeast and the Onset of Mid-Holocene El-Niño/ENSO Events: Is There a Connection?" In *Man—Millennia—Environment: Studies in Honour of Romuald Schild*, edited by Zofia Sulgostowska and Andrzej Jacek Tomaszewski, 133–41.

Warsaw: Institute of Archaeology and Ethnology, Polish Academy of Sciences.

Saunders, Joe. 2007. Untitled and unpublished draft manuscript on file with the Poverty Point Station Archaeology Program, Epps, LA.

———. 2010. "Late Archaic? What the Hell Happened to the Middle Archaic?" In *Trend, Tradition, and Turmoil: What Happened to the Southeastern Archaic?* edited by David Hurst Thomas and Matthew C. Sanger, 237–43. New York: American Museum of Natural History.

Saunders, Joe W., and Thurman Allen. 1994. "Hedgepeth Mounds, an Archaic Mound Complex in North-Central Louisiana." *American Antiquity* 59:471–89.

Saunders, Joe, Thurman Allen, Dennis LaBatt, Reca Jones, and David Griffing. 2001. "An Assessment of the Antiquity of the Lower Jackson Mound." *Southeastern Archaeology* 20:67–77.

Saunders, Joe W., Thurman Allen, and Roger T. Saucier. 1994. "Four Archaic? Mound Complexes in Northeast Louisiana." *Southeastern Archaeology* 13:134–53.

Saunders, Joe W., Rolfe D. Mandel, C. Garth Sampson, Charles M. Allen, E. Thurman Allen, Daniel A. Bush, James K. Feathers, et al. 2005. "Watson Brake, a Middle Archaic Mound Complex in Northeast Louisiana." *American Antiquity* 70:631–68.

Saunders, Joe W., Rolfe D. Mandel, Roger T. Saucier, E. Thurman Allen, C. T. Hallmark, Jay K. Johnson, Edwin H. Jackson, et al. 1997. "A Mound Complex in Louisiana at 5400–5000 Years before the Present." *Science* 277:1796–99.

Scharf, Elizabeth A. 2013. "Pollen and Charcoal in Sediments from the Swamp West of Mound A at Poverty Point State Historic Site (16WC5), Louisiana." Unpublished report on file with the Poverty Point Station Archaeology Program, Epps, LA. Grand Forks: University of North Dakota.

Seeman, Mark F., Nils E. Nilsson, Garry L. Summers, Larry L. Morris, Paul J. Barans, Elaine Dowd, and Margaret E. Newman. 2008. "Evaluating Protein Residues on Gainey Phase Paleoindian Stone Tools." *Journal of Archaeological Science* 35:2742–50.

Silverberg, Robert. 1989. *The Mound Builders*. Athens: Ohio University Press.

Suter, Charles R., and A. E. Blaisdell. 1874. "Map of a Reconnaissance of the Mississippi River, from Cairo, Ill. to New Orleans, La. to accompany the Report on that portion of the third subdivision of the Mississippi Route to the Seaboard made in accordance with an Act of Congress approved June 23rd, 1874." Washington, D.C.: U.S. Army Corps of Engineers.

Waters, Michael R., Charlotte D. Pevny, David L. Carlson, and Thomas A. Jennings. 2011. "Usewear Analyses of Clovis Artifacts." In *Clovis Lithic Technology: Investigation of a Stratified Workshop at the Gault Site, Texas*, 135–51. College Station: Texas A&M University Press.

Webb, Clarence H. 1982. "The Poverty Point Culture." In *Geoscience and Man*, vol. 17, 2nd ed. Baton Rouge: Louisiana State University School of Geoscience.

Woodiel, Deborah. 1990. "Investigations at the Visitor Center, Poverty Point State Commemorative Area, 1978." *Louisiana Archaeology* 13:41–71.

INDEX